Literary Butte

A History in Novels & Film

AARON PARRETT

THE
History
PRESS

Published by The History Press
Charleston, SC 29403
www.historypress.net

First published 2015

Manufactured in the United States

ISBN 978.1.62619.836.4

Library of Congress Control Number: 2014956339

Notice: The information in this book is true and complete to the best of our knowledge. It is offered without guarantee on the part of the author or The History Press. The author and The History Press disclaim all liability in connection with the use of this book.

Much of the current romance of Butte is the doomed romance of ruin, of traces and whispers and ghostly things that aren't readily graspable. History, we must remember, is the study of the invisible, a refusal to let bygones be bygones, the academic equivalent of an endless wake.
—*Edwin Dobb*

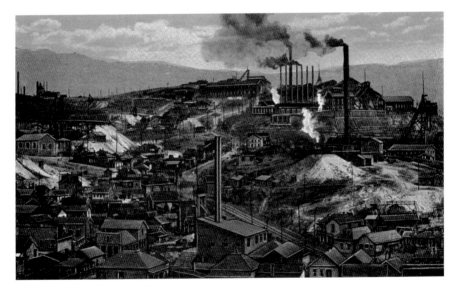

"Richest Hill on earth" postcard, circa 1916. Artist unknown. *Collection of Aaron Parrett.*

CONTENTS

CONTENTS

FOREWORD

For any Montana-born writer and artist, there are two roads one should explore—the wilderness and Paris. Nature needs no exotic adventures abroad, no cities on the Silk Road to visit. The subject is literally under our feet—most often writers come from elsewhere to extol beauty and to tell fish stories (notably excepting Norman MacLean, who saw the dark tragedy inherent in both human nature and the wild). Looking about, I found it disappointing how few writers had called upon the sulphurous exhalations of the Yellowstone basin to flesh out their narratives or metaphors.

In the 1970s—after returning from travels in North Africa and Europe and a prolonged residence in San Francisco—I began to explore the idea of a cowboy-surrealist Montana. I had ambitions then to become a publisher of art and literature and was seeking to upholster my account with homegrown examples of "unprecedented extrusions of the Marvelous."

I was led immediately to Butte, where even the gravel exudes nightmarish mineral extremes. It was the vitriolic tongue of Mary MacLane that exemplified for me the desperation that had propelled me in my early adventures in Paris and Tangiers. I enlisted Mary as a literary ancestor just as André Breton had once enlisted the Comte de Lautréamont—as a symbol of extreme and deviant egotism. Comparing *The Story of Mary MacLane* to *Les Chants de Maldoror*, I found similar and dangerous correspondences that can potentially lead a reader away from the straight and narrow path. As a self-styled literary desperado and an impatient young man, I detested that narrow path.

To explore the deeper canyons of the human condition, writers more often look into a man's character with its roots deep in elsewhere, and it is from elsewhere that the call comes the loudest: the elsewhere of political murder rooted in the greed of mining companies with corporate headquarters in Boston and Manhattan and San Francisco, the elsewhere of Cornishmen, Finns and Chinese laborers—their stories, like Butte's, bubbling up from deep chthonic springs. In the case of Butte, the springs are heavily contaminated.

Wherever men dig deeper than the surface, they uncover and release unpalatable substances that are not necessarily beneficial to their health. In art, we seek respite from these ugly truths of our existence, refuge from the grind of survival in the hostile environments of murder, substance abuse, arsenic in the water and sulphurous smoke in the air.

All of which leads us directly to Butte. And to Aaron Parrett's critical history of the literature that feeds upon Butte and serves to alleviate the pent-up pressures that the extrusions of the marvelous produce.

PETER KOCH

ACKNOWLEDGEMENTS

Thank you…to my wife, **Nann Parrett**, and our daughter **Maizy Θ Lorraine**, who both inspire me and who gave me the time alone to write when I needed it; to my friend **Bill Borneman**, philosopher and collector; to fellow Buttician **Edwin Dobb** for sharing his insightful Butte sensibility and a lot of great conversations besides; to **Brian Shovers** and all the crew at the Montana Historical Society, including **Zoe Ann Stoltz** and **Rich Aarstad**, who are knowledgeable, patient and helpful; to **Allen Jones** for good advice along the way and general encouragement; to **Artie Crisp** for great conversation and suggesting the project in the first place; to my good friend **Lyle Williams**, who shared his love of Butte and his great collection of Buttiana; to **Monika Vykoukal** at the International Workers of the World who shared a photo of **Frank Little**, and to **Wayne State University**, which supplied the image; to my former comp-lit comrade **Chandra Jackson**, who gave me the secret password; to the great and trusting people at the **Butte–Silver Bow Archives**; to my parents, **Bonnie and Chuck Parrett**, who both had the good sense to be born in Butte to make sure that I was, too; to **Gretchen Metz** for the lovely photograph of Francis James Rabbitt; to **Jane and Michael Duffy** for some great conversations about Joe Duffy and for sharing a great photograph of him; to Professor Emeritus **Earl Ganz**, who inspired me to look at Butte in a whole new way and shared his understanding of Myron Brinig, along with some great photographs; to **Molly Holz**, who was the first to look at any of this and suggest hope; to **Fred Quivik** for his prodigious knowledge of Butte

mining and for his valuable advice and suggestions; to **Richard Gibson** for *Lost Butte* and good advice along the way; to my friend and colleague **Jo Anne Church** for her advice and editing; to my aunt and uncle **Cheryl and Lou Parrett** for always giving me a place to crash when in Butte; to librarian extraordinaire **Sue Lee** at the University of Great Falls; to **Kristi Hager** for loaning her copy of *Bell Diamond*; to **David Mariani** for finding things I couldn't find; and to **Doug Hawes-Davis** for connecting me to Artie Crisp.

BUTTE, AMERICA

She's ugly, you say, old Butte is,
And grimy, black and drear,
Why, partner, I never could see it,
And I've lived here many a year.
There's nothing pretty about her,
But somehow she's strong and free.
And big and rugged and—well, comrade—
She looks pretty good to me.
—Berton Braley

Butte, Montana, clings white-knuckled to a flank of the continental divide. At night, the lights of the uptown seem to spill down into the flat as if someone poured out a sack of jewels, but by day, you see a gritty, rough-hewn city on a hill clinging precipitously to the edges of what was once the world's largest open-pit copper mine, the Berkeley Pit. The town emerges from a landscape of sagebrush and tenacious conifer forest among outcroppings of granitic rock, bordered to the south and the west by impressive alpine peaks—the Highlands and the Anaconda Range—and hemmed in on the east by a steep wall of sharp hills known as the East Ridge.

To visit the city of Butte today is to step back into another time: the uptown resembles a smaller version of Chicago or Milwaukee or even San Francisco with its city blocks of Gilded Age brick buildings, many of them now abandoned or refurbished, narrow avenues and alleys lined with the

remnants of once-fabulous storefronts and nightclubs. And like distant cousins of fin de siècle skyscrapers, a dozen towering headframes still rise above the mouths of the old mines that operated before the pit began to swallow the town.

From a geographical perspective, it's somewhat baffling that Butte exists at all. As Alexander Winchell observed in 1911, "Butte is an excellent example of a city built and prosperous in spite of the fact that all those external conditions generally thought of as 'geographic' are extremely unfavorable: Butte has no natural water supply; it has no natural fuel supply; it has no natural routes for transportation; it has not even a natural food supply."

Almost from its inception in the 1860s, those who have visited the place agree that there's no place quite like it on earth. The earliest prospectors were taken by the high alpine setting and the "colors" that showed in their pans, but it wasn't long before more serious miners realized the hill held a bonanza of precious metals of unprecedented magnitude. What might easily have boomed briefly but become just another quaint ghost of a mining town indistinguishable from hundreds of others just like it has instead achieved immortal fame as "the richest hill on earth," nourished by the legends of its Copper Kings and the panoply of characters who wandered its streets when Butte was in its prime.

In the same years that Butte evolved as an industrial colony and proving ground for some of the world's richest and most rapacious capitalists, the Butte hill also stood as a beacon to laborers and union men everywhere, calling the oppressed to action as the country industrialized, from the beginning of the Gilded Age right up through the Depression: Woody Guthrie, Pete Seeger, Utah Phillips and Mark Ross sang on its streets, and modern icon of labor Frank Little was martyred—hanged by the neck from a railroad trestle with the old vigilantes' mark, 3-7-77, pinned to his chest. Long considered an ugly place, the town has lately become an especially hideous symbol of corporate irresponsibility and industrial poisoning as it now holds in the bosom of the Berkeley Pit over one billion cubic feet of highly toxic water, making it one of the chief Superfund sites in the United States.

Throughout the entire course of its often sordid history, however, the spirit of its inhabitants has been indomitable. Residents of Butte have always taken a kind of quiet pride in the very ugliness that surrounds them. For them, the garish eyesore of the immense pit is merely the latest scar the town has been forced to bear. Famous throughout Montana, "Butte pride" is a high-octane distillation of rural American sentiment, one of the more volatile vapors of

which is a firm dedication to the working classes. Unlike many of the more rural parts of Montana, votes cast in Butte are a solid shade of blue.

In many ways, that pride epitomizes the history of the town. In the nadir of its economic woes in the early 1980s, the chamber of commerce, as part of its plan to rejuvenate the city, printed thousands of bumper stickers that simply said, "Butte, America." Butte truly is a kind of microcosmic crystal of the entire country, a perfect intersection of its problems and its promise, an unintended travesty of John Winthrop's "city on a hill."

It makes sense, then, that an astonishing number of writers have chosen Butte, Montana, as the setting for their work. However noble or ignoble the narrative of Butte may be, it is in some sense an abridged version of the story of America itself: a story of people from nearly every corner of the world who found their way to labor there in pursuit of its promised wealth and an ensuing saga of the battle between forces of unbridled capitalism and social justice. In 1970, novelist Richard K. O'Malley telescoped two hundred years of American history when he took this snapshot of Butte in his classic *Mile High Mile Deep*:

> *Irishmen working as far south as Leadville, Colorado heard about the Butte strike. And Finns sweating it out in the Minnesota iron workings heard about it. And the Swedes and the Cornishmen and the Montenegrins and the Italians and the Yugoslavs and the Norwegians heard about it. And the Greeks, too, but they thought in terms of restaurants; working men have to eat. And the gamblers from everywhere. They all came to Butte. They filled its dirty streets with the noise of a dozen tongues and they filled its tunnels and stopes and manways with themselves and the sound of buzzies biting into the rock was loud, down below.*

The ethnic diversity of Butte was just one factor that set the city apart from most of the rest of Montana. Industrial blight was another. Even today, tourists don't travel to Butte expecting to find blue-ribbon trout streams or trailheads in old-growth forests. Aesthetically, Butte has more in common with Pittsburgh or Cleveland than it does with Bozeman or Missoula. This may explain why dozens of popular writers in the last half century, including bestsellers like Kathleen Winsor (*Wanderers Eastward, Wanderers West*, 1965), for example, and Henry Sutton (*The Exhibitionist*, 1967) worked Butte into narratives that ultimately have little to do with Montana. Several recent novels, including Sandra Dallas's *Buster Midnight's Café* (1990), Reif Larsen's *The Selected Works of T.S. Spivet* (2009) and Pauls Toutonghi's *Evel Knievel*

Days (2012), seem to use Butte as a setting mainly because of its unusual features and colorful history rather than because of its location in Montana. Butte provides an immense vault of narrative inspiration for writers in part because it was a cosmopolitan city, even if it happened to exist in one of the least populated states. And the hefty catalogue of real-life characters who played roles in the course of its history easily aligns with the tableau of the American story writ large.

This book is the first comprehensive study of the remarkably broad stream of literature and film to flow from Butte, covering works that appeared not long after the city was laid out in 1865 all the way up to novels that have appeared in the last few years. This study indirectly catalogues Butte's colorful history, beginning with its inception as a gold and silver camp, up through its development as one of the leading copper producers in the world, into the post-mining era that has left Butte scrambling to forge a post-industrial economy out of the architectural remnants of a once-thriving metropolis.

Though the novels considered here were published across a span of more than a century, a handful of common themes within them may be clearly discerned, chief among them a tendency to personify the city as a character with an identity all its own. It's a chicken and egg argument whether Butte's fame as a city *sui generis* has led so many writers to choose Butte as a setting or whether its fame derives from all the novels written about it. Either way, the whole reciprocal process is a kind of cultural dynamo that has kept the place thriving even in the lean years. Butte may be *sui generis*, but it is also, in its mythology, autochthonous.

The literary history of Butte exposes some faults in the conventional wisdom regarding mining camps as the exclusive prerogative of men, since at least a third of the collection discussed here were penned by women, and even in most of the books by men, the female characters exude strength and self-reliance. As several twentieth-century historians of Butte—Mary Murphy, Ellen Crain and Janet Finn, to name just three—have emphasized, the history of Butte is in many ways a story both told by and *lived* by women.

Another perennial theme in the literature of Butte is the presentation of an often violent struggle between labor and industry, a theme that often converges with the theme of political corruption—a disease whose symptoms presented at every level of power, from crooked cops walking their beats uptown to state legislators who were essentially bought and paid for with company money.

During the pioneer years, Montana was well known for the scandal of its lawlessness and vigilantism, which became even more acute during its

political scandals around the turn of the century. If in the 1860s Montana was seen as the essence of the lawless West, by 1900, Butte had become a familiar emblem of corporate and political corruption. A key aspect of what "the West" was coming to mean was not so much a geographical concept as a cultural one, a shift in sensibility that also contributed to the *idea* of Butte. "The West" referred as much to a way of doing business and developing enterprises as it did to a particularly bounded region of the country. Butte exemplified the culture and atmosphere of what Mark Twain called "the Gilded Age," marked by extremes of wealth and poverty. Images of Butte often contrast shoeless and filthy urchins playing on tailings piles against the affluent neighborhoods on the west side, with their meticulously landscaped gingerbread homes built by the corporate executives. Gilded Age disparity was pandemic in the West but especially acute in Butte.

Writing in the *Century* in 1903, Ray Stannard Baker observed that "the most western of cities is not Portland or Seattle, but Butte City, six hundred miles to the east of the coast." Baker was trying to express to easterners the difficult idea that, as he put it, "what we call Western is singularly misplaced in the West," at least outside Butte. Ever since Frederick Jackson Turner confounded historians in 1893 with his controversial "frontier thesis," academics and cultural geographers have been arguing about precisely what is meant by the phrase "the West" in the first place, although the concept of "the frontier," a term no more lucid, seemed to be a critical part of it.

But in the late nineteenth century, at least one of the things "the West" meant in the collective imagination of Americans was a part of the country beyond firm reach of the law. The West may not have been the abject state of anarchy it was in the 1850s and 1860s, but it nevertheless operated in the last decades of the nineteenth century with considerably less judicial oversight than did the rest of the country. And nowhere was this as plainly evident as in Butte, Montana. As Christopher Connolly wrote in his inimitable history of Butte called *The Devil Learns to Vote*, "This struggle between mining magnates of almost limitless wealth made hundreds of men and ruined thousands; it perverted the moral sense of entire communities; it destroyed promising careers, and checked worthy names from the scroll of state and national fame. It corrupted the machinery of justice, and placed the lawmaking power on the auctionblock."

One other salient fact emerges from the present survey: the majority of novels associated with Butte happen to be set during a twenty-year period from 1890 to 1910, known as "the War of the Copper Kings." That largely political battle segued into a period of corporate finagling and consolidation

that achieved its zenith with the triumph of the Standard Oil–backed Anaconda Company. This period in Montana history amounts to a sort of hypertrophied narrative of the Gilded Age. It makes sense that, no matter what time period they happen to live in themselves, writers would be drawn to this era, ready-made as it is for the stuff of high drama. The more convincing writers who do so—Richard Wheeler, for example—succeed in their efforts because they show how historical mistakes have a way of haunting us in the present, driving home the point that the Gilded Age in fact looks very much like our own.

But a majority does not mean a totality, and many other worthy books ignore that well-traveled historical path, choosing instead to explore other elements of Butte's story, confirming the conclusion that the literature of Butte is more than a motley of novels about the Copper Kings. The fact that so many of the novels about Butte hardly mention the boom years or the Clark-Daly feud is itself evidence that the story of Butte continues to be an American story. The literature of Butte is a diverse library of narratives that continues to add new books to the stacks.

Only one previous short study devoted exclusively to novels associated with Butte exists, and it appeared nearly thirty years ago. Written by one of Montana's most revered historians, Richard Roeder, it takes a rather dim and—one could argue—narrow view of the works about Butte. As a result, Roeder comes off as slightly sclerotic, ready to cull nearly everything from the shelves. He grudgingly admits that a few of Myron Brinig's novels occasionally shine, but his ultimate judgment is that "Butte has not been the source of a great American book," a statement that strikes contemporary ears as slightly modernist and cranky. For that matter, elsewhere in reference to Butte novels, Roeder called *Perch of the Devil* "the best of them," an assessment with which I doubt any other reader—historian or literary critic, postmodernist or modernist—would concur. To be fair, Roeder did rescue some of these books from the discard pile, such as James Francis Rabbitt's *High, Low, and Wide Open*, but one wonders why he bothered at all to document a collection on which he lost so little love. Roeder died in 1995 and missed the opportunity to appreciate some works that have appeared more recently, but he overlooked completely a considerable number of older works, including those of Josephine Bates, Gerald Lutz and David MacCuish, three authors certainly worthy of attention, even if none of them won a Nobel Prize.

Speaking of history, a certain class of cynics likes to suggest that in the end, one can't very well distinguish history from fiction, since "the truth" always depends on who is telling the story. That may be true as far as it goes,

but a welcome corollary of that proposition—too often lost on those same critics—is that fiction is often uncannily adept at capturing the spirit of an age, even if it is not entirely conscientious about facts: one stands to gain a better understanding of what Chicago *felt like* in 1890 by reading Dreiser's *Sister Carrie* (1900), for example, than by plodding through Bessie Pierce's meticulous *History of Chicago* (1957). Though fiction is by its very nature "made up," it strives for what literary critics call *verisimilitude*—a Latin word that means "like the truth" and that carries in its English usage a sense of a story told so well that it certainly *could* be true. Accordingly, fiction often preserves the past by bringing it alive, quite in contrast to history, which all too often, as one critic famously put it, reduces itself to "polishing tombstones."

One could reasonably argue that the discipline of history stands to benefit from the literary survey just as much as a novelist stands to benefit from a historical review of the time period surrounding the novel she's writing. The record of the world captured for posterity in a well-written novel ensures that history does not have an expiration date, that one does not need always to resort to footnotes, mothballs or formaldehyde to preserve the past. As the Pulitzer Prize–winning historian Jack Rakove has observed, "The composition of any narrative history requires decisions as to perspective and dramatic structure that differ little from the imaginative contrivances of the novelist."

While the history of Butte can be divided into different periods in various ways, it goes without saying that such divisions are never discrete or tidy. This problem is confounded because a literary study of a collection of novels that by virtue of their subject matter may all be classified as "historical" puts the reviewer in a dilemma: arrange the discussion in order of the time period in which the various books are set, or arrange them according to the order in which they were written? I have chosen the latter course, but it may be worth pointing out that in general, Butte history may be divided into five periods: the gold placers of the 1860s; the years of silver mining up to the 1880s; the ascendancy of copper and the War of the Copper Kings (1879–1910); the consolidation of the Anaconda Copper Mining Company and its hegemony lasting up to the 1980s; and the post-mining era leading from the 1980s up to the present. This survey looks at works from every one of these periods except the first. The chapters are arranged in historical order, considering the books roughly in the order in which they were written and not according to the time periods that they happen to cover.

It should also be noted that this study does not purport to be exhaustive or approaching anywhere near the analytical depth that the literary works of

Butte deserve. What you hold in your hands now amounts to little more than a field report filed by a literary prospector in the fervent hope that others will continue to seek out the lodes of literary ore running through the richest hill on earth.

Chapter 1

BEFORE THE COPPER KINGS

Josephine White Bates and *A Blind Lead*

*Away in the past ages some restless force at work in the earth's interior had rent
the ancient hillside and heaved the molten lava high into the outer world. It had
cooled a solid cone, and stands now a mass different from the country rock around,
an alien in birth and an alien in nature.*
—Josephine White Bates

The inimitable Mary MacLane is generally credited as being the
first literary writer to come out of Butte, Montana, and Gertrude
Atherton is generally credited with having written the first "Butte" novel.
The Story of Mary MacLane appeared in 1902, and Atherton's *Perch of the
Devil* came out in 1914. Atherton had published seventeen novels prior to
her Butte novel and was a seasoned writer traveling in circles that included
Henry James and William Dean Howells. Mary MacLane, by contrast, was
a nineteen-year-old young woman when she wrote her story (which she
originally titled *I Await the Devil's Coming*) and was only twenty-one when it
first appeared on booksellers' shelves. It turns out, however, that both of
these women were preempted by yet another young woman who published
her novel about Butte in 1888, less than a decade after Butte City was
first incorporated, fourteen years before *The Story of Mary MacLane* and a
quarter century before *Perch of the Devil.*

In *A Blind Lead*, readers will find no mention of the Copper Kings or
Venus Alley, no wistful appreciation of the lights on the hill at night, no
woeful tales of union struggle—in fact, almost none of the features we

have come to expect in any novel about Butte. This is because Josephine White Bates wrote her novel prior to 1887 (very likely she began it in 1885), before Marcus Daly and William A. Clark began their feud and long before Augustus Heinze commenced his feats of legal legerdemain. In short, her novel belongs not to Butte's copper age but, rather, to its silver age.

Like nearly every other town in southwestern Montana, Butte got its start as a gold camp—a string of claims and shacks stretching for a couple of miles along a small stream cascading down out of the mountains of the continental divide and meandering west into the head of the Deer Lodge Valley. The first strikes of any consequence in Montana had occurred a few years earlier when gold was discovered at Bannack and Virginia City in 1862. Another rush followed in Helena in 1864, around the same time that prospectors started to seriously work the Silver Bow drainage. The gold that prospectors washed out of the placers along Silver Bow Creek was respectable but not in sufficient quantity to precipitate a gold rush of Virginia City proportions. Seasoned prospectors who had drifted up from Nevada and Colorado, however, recognized the evidence of other metals—most notably silver—augmenting the gold, which encouraged them to work their way up the creek to its source along what is now known as the Butte hill.

While miners continued to recover gold, by the 1870s, the gold placers along Silver Bow Creek had given way to silver mining, which required

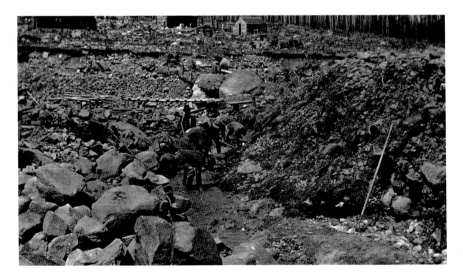

A postcard image of placer miners near Butte, date and photographer unknown. *Collection of Lyle Williams.*

an entirely different approach, namely the sinking of vertical shafts and horizontal workings below ground to follow the veins of ore, also known as lodes or leads. In an essay called "The Independence Mining District: 1880–1887," historian Ellen Crain notes that "in the early 1880s, Butte was referred to as the 'Silver City.'" In 1884, silver boomed in the Butte area with the development of the Independence District (adjacent to and immediately west of the Butte District). The silver mines came into production when mining was still a relatively simple affair, but they quickly adopted the steam-powered and electrical improvements that would make copper mining possible on a vastly increased scale. For example, in 1884 in the Independence District, Crain writes, "there were well over 18 mines actively producing and an average of 15 men working each shaft." Crain explains that in the early 1880s, a lack of technology limited the mines to depths of at most several hundred feet. Even as late as 1896—after the advent of steam and electrical power—according to *Western Mining World*, only fifteen of the hundreds of Butte mines were deeper than 1,000 feet, none was deeper than 1,500 feet, and the vast majority were between 200 and 600 feet. By 1885, copper mining and smelting were the dominant factors in the Butte economy, according to historian Fredric Quivik, though silver was also booming. In the year 1884, one thousand men were working the hill, a figure that would be dwarfed by the estimated sixteen thousand men going underground every day in the peak of the copper years a few decades later. Josephine Bates and her husband lived in Butte in the midst of that silver boom. Hence, unlike any of the dozens of other Butte novels, the focus in *A Blind Lead* is on silver mining.

A Blind Lead weaves together two overlapping plots. The main plot from which the book takes its name follows the miner John Howard in his efforts to pursue a silver lead that he feels certain will lead to a rich vein, making his fortune and thereby securing a better standard of life for him, his wife and their children. His exhausting toil underground in a shaft he has sunk himself takes its toll, threatening his health, while his family suffers in poverty while holding out for his success. The subplot follows the heroine, Ellen Rayburn, a schoolteacher who is courted by two men. The first is the young, handsome and charismatic Jerold Bray, a miner who works for other men who have staked claims on the Butte hill, including John Howard. Ellen's other suitor is Robert Hall, the wealthiest man in town, a quiet and reserved fellow who suffered the loss of his wife and children a few years prior. In spite of his wealth and success as a mine owner, Hall is hardly the sort of unfeeling capitalist one encounters, for example, in a Dickens novel; in fact, he is

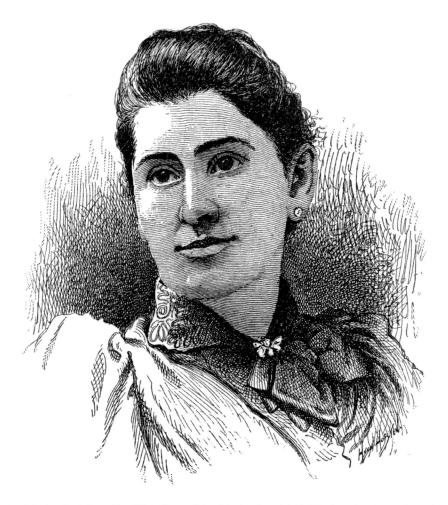

An ink sketch of Josephine White Bates (Mrs. Lindon Bates) in 1880, the year she graduated from Lake Forest College. Artist: Hugo Von Hofsten. *Courtesy of Anne Thomason, Lake Forest College, Illinois.*

rather a paragon of moral virtue in all respects. He anonymously provides support to a needy family and gallantly withdraws from pursuing Ellen when she confesses her love for Jerold. The two plots intertwine because Ellen is sister to John Howard's wife, Elizabeth, and aunt to John and Elizabeth's daughter Ada, with whom the rakish Jerold begins an affair. The novel is a tragedy of unrequited love in the vein of many nineteenth-century novels.

The novel is hardly a roman à clef, but given that *A Blind Lead* takes place in the era in which Butte was becoming a booming silver camp, certain

elements of John Howard's single-minded and indefatigable pursuit of a silver vein on the Butte hill do seem to echo the exploits of real-life figures such as William Park, erstwhile gold prospector, who in 1868 had sunk his Parrot mine (No. 1) to a depth of 155 feet using only hand tools. A few years later, William Farlin took advantage of a recently enacted law that allowed unworked claims to be reclaimed by other parties, and he found similar silver riches on abandoned ground that became the famed Travonia mine. Both men sank their shafts with primitive equipment, laboriously lifting waste rock out with hand-cranked windlasses. Indeed, these are methods John Howard uses in *A Blind Lead*. Through the efforts of these early hard-rock men who pursued the silver leads, Butte escaped the fate of innumerable other gold camps that faded into ghostly oblivion when their gold placers were exhausted. Instead, by 1875, according to the writer of *Copper Camp*, "the town as a silver camp quickly took on an air of stability."

Bates renames the town "Colusa," after a pair of well-known mines in Butte. In fact, the actual Colusa properties (known as the East Colusa and West Colusa) had been acquired in 1873 by future copper magnate William A. Clark, who, because the mining camp was still so primitive, had been compelled to ship a test sample of its ores out of state for processing. He sold the promising pair of claims in 1876 to Charles T. Meader, for whom Meaderville was named.

Although copper was first discovered in 1876 on the Butte hill, the pursuit of silver remained preeminent until Marcus Daly completed his Anaconda Reduction Works at Anaconda, Montana, in 1884, and it was not until the 1890s that the crash of the silver market and the increased demand for copper wire for electricity converged to bring copper into widespread industrial focus. The repeal of the Sherman Silver Purchase Act in 1893 sealed the fate of silver miners, who had essentially only been kept afloat for the previous three years by the act, which required the federal government to buy millions of ounces of silver, an obvious form of artificial subsidy. And yet Butte endured because in addition to the gold and silver lay rich deposits of copper.

In his classic study, *Western Mining*, Otis E. Young deftly summarized the progression of mining development as a natural sequence of ores:

> *Ground water tends to dissolve metallic sulphides selectively, carry them down the lode, and redeposit them in the rich but shallow concentrations which mark the oxidized zone. Copper is the metal most readily carried down, silver the next, and gold the last. As erosion lowers the mean surface,*

the gold is exposed first, and unless placered off, will tend to move laterally into the stream beds as dust and nuggets. It is next the turn of the silver to be exposed, gradually reducing to native metal, and then removed by erosion. Copper comes next, leaving iron, and so on…Thus, what starts out as a gold placer becomes a silver mine…Marcus Daly at Butte found the same sequence and capitalized upon it. [*]

Josephine Bates's novel, aside from its literary merits, should attract the attention of historians simply because she alone among these early novelists dealing with Butte captures that brief interval between the gold placers and the huge copper concerns during which silver was often assiduously pursued. Whereas gold is often easily recovered in pure form as nuggets, flakes or dust from placer operations, the pursuit of silver invariably involves hard-rock mining, which means ores must be collected and then crushed in stamp mills. That product must either be amalgamated with mercury and further processed or roasted in furnaces in order to recover the metal. Bates vividly depicts how labor intensive such mining is, showing her characters exhausting themselves in following leads.[†]

Josephine White Bates was born in 1857 in Canada and enjoyed a rather illustrious life, though she did not achieve enduring success as a writer. She was unusually well educated for a woman of her era, graduating in 1880 from Lake Forest College in Illinois. In 1883, she married Lindon Wallace Bates in Portland, Oregon, where she also gave birth to the first of her two sons. Shortly after their marriage, the Bates family moved to Butte, where Bates circulated among the well-heeled investors and mine developers. The Butte City Directory for 1885 lists him only as "a Capitalist," not specifying precisely what occupation he pursued at the time, though other sources suggest that his time in Butte was spent in the employment of the Union Pacific Railroad, which had reached Butte only a few years earlier. Lindon Wallace Bates became well known as one of the country's leading civil engineers, recognized for his reclamation work in Galveston in 1902 following the devastation caused by the 1900 hurricane and subsequent

*. Other experts point out that Young's summary, while generally accurate, does not apply completely in the case of Butte, where the mineralization was more complex, creating different zones in which certain metals preponderated; it so happens that silver appears in deeper zones than Young suggests on the Butte hill. See, for example, Walter Harvey Weed, "Geology and Ore Deposits of the Butte District, Montana" (USGS Professional Paper 74) 1912, 94.

†. A similar tale of life in an early day mining camp had been written by Mary Hallock Foote, also the wife of an engineer, in her 1883 novel, *The Led-Horse Claim: A Romance of a Mining Camp* (Boston: Osgood).

flood. In the years leading up to World War I, Lindon Bates frequently made the news for his engineering efforts in Panama, where he is credited with devising the "three-lake plan" for completing the canal. In 1914, along with her son Lindon Bates Jr., Josephine rallied Americans to contribute to the Belgian relief effort. In 1915, Lindon Bates Jr. perished in the sinking of the *Lusitania*, an event that led to American involvement in World War I, and this galvanized his mother as an ardent hawk. The Bates family was among New York City's most elite families (they maintained a Fifth Avenue address) and were personal and close friends with Mr. and Mrs. Herbert Hoover.

While Mr. Bates advanced his career as a civil engineer, Josephine Bates made a name for herself as a luminary in the intellectual circles cultivated by women of the era known as "women's clubs." In *The History of the Woman's Club Movement in America* (1898), Jennie June Croly records in the proceedings of the Atlanta Council of the General Federation of Women's Clubs in 1895 that "perhaps of all the papers given at the congress that of Mrs. Lindon W. Bates upon the office of literature was the most valuable. The great element of literature, she said, is power, and the use of literature is to create and present idealities." Though few women were educated to the extent that Bates was in the late 1800s, it is worth pointing out that outside of colleges (which catered almost exclusively to men), women's clubs such as those Bates conducted were responsible for intellectual and cultural outreach in most local communities. What is even more unusual in her specific case is that she not only cultivated the liberal arts and an appreciation of literature through her connection to such clubs, but she also wrote literary works in her own right.

Josephine White Bates wrote several fictional works in addition to *A Blind Lead*, including *A Nameless Wrestler* (1889) and *Bunch-Grass Stories* (1895). In a showcase of writers in *Munsey's Magazine* called "Literary Chicago," Moses P. Handy praised her as "an interesting storyteller whose work is saturated with the best flavor of the western soil." William Morton Payne reviewed Bates's *Bunch-Grass Stories* in *The Dial*, remarking that "[t]heir direct, picturesque, vivid quality stirs the blood with a keen sense of the robust life which they depict." He paid her a backhanded compliment in the chauvinist idiom of the time by noting that the most striking thing about her stories was "that they should have been written by a woman, for their point of view is distinctly masculine." Bates also wrote a celebrated piece of muckraking called *Mercury Poisoning in the Industries of New York City and Vicinity* in 1912, which continues to be referenced today in studies of environmental contamination.

Her husband having died in 1924, Josephine in her later years found herself compelled to sue Germany for financial recompense for the death

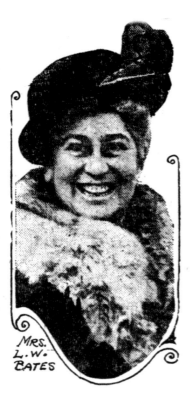

An image of Josephine White Bates (Mrs. Lindon Bates) in 1916. Mrs. Bates's son had died the previous year in the sinking of the *Lusitania*, after which she became a vocal advocate for U.S. entry into World War I. *Image from the* Chicago Day Book, *May 13, 1916. Courtesy of the Illinois Newspaper Project.*

of her son, arguing that his premature death deprived her of a caretaker for her autumn years. Both her husband and her son were dead, her surviving son was unable to provide for her and her own literary career hardly offered any remuneration at all. Josephine enlisted longtime friends President Herbert Hoover and his wife in support of her cause. The judgment of the international commissioner reviewing the case was that Josephine Bates was entitled "under the Treaty of Berlin" to a settlement in the amount of $25,000 on September 19, 1924. She spent her autumn years in New York City and New England. She died in 1934 of a heart attack.

A Blind Lead: The Story of a Mine was the first literary effort by a writer who would go on to write at least four other books, two of them fiction. Unfortunately, her first book has been almost wholly forgotten by modern critics. When Bates is mentioned at all or referenced in regional anthologies of the period, her *Bunch-Grass Stories* draws attention to the neglect of this singular novel. Bates's debut work is hardly perfect—the writing is often stilted, and her circumlocutions require more effort than they are often worth—but aside from its defects, *A Blind Lead* tells a convincing and compelling story, peopled with believable characters with whom even modern readers can relate. At moments, in fact, the dialogue seems surprisingly modern for 1888. More importantly, from a historian's perspective, *A Blind Lead* offers a rare documentary look at an important, if also neglected, sliver of Butte history.

Bates describes the rough squalor of early mining camp life with compelling detail, documenting the "rough-hewn logs and mud-mortar" of which the crude cabins are composed, for example, and each cabin

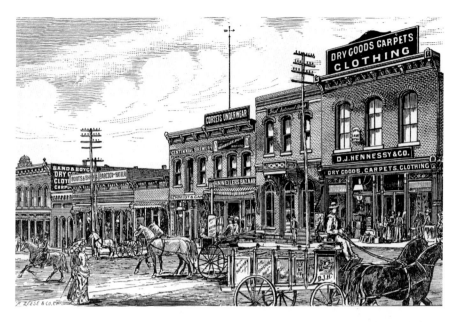

An etching of West Main in Butte looking from Granite to Broadway. From *The Holiday Edition of Inter Mountain*, 1887. P. Zeese & Co. Chicago Artist. *Courtesy of Montana Historical Society Research Center Photograph Archives, Helena, Montana.*

with the "same unplaned doors, small square windows, and projecting dirt roof." Bates's depiction of Butte as it was making the transition from a rowdy collection of shacks and diggings to the western metropolis that it would become corresponds to descriptions in many later novels, although her narrative remains unique among novels in its presentation of the town before copper. "A mining camp is like no other place on earth," she writes, "there is a fascination about it that is inexplicable, a spirit of enthusiasm that is contagious."

By the time most of the other nineteenth- and early twentieth-century novels about Butte appeared, the once modest "mining camp" had burgeoned into a full-blown industrial city, with steel head frames in place of timber windlasses, frame houses where log shacks had once been hastily put up and stately Victorian brick buildings now lining cobblestone thoroughfares where cabins had formerly stood among mud alleys. By the close of *A Blind Lead*, Colusa (Butte) has changed from a collection of rude huts to a promising western town: "The one business had now grown to three. The primitive log house of the early miner had in many cases been disguised by a pretentious front, and was doing duty as a grocery or saloon, for the camp was aspiring

29

to the dignity of a city." The narrator describes "newcomers" freshly arrived from Arizona, bent on buying up individual claims in the effort to consolidate them into monopolistic operations like those in Arizona and Nevada. The miner John Howard cannot hide his cynicism in explaining to his wife how "we poor cusses enters a claim, puts in our work an' opens her up; then when th' ore's in sight an' we're bust through developin,' long comes one uv them 'ar money fellers, buys it up fer a song an' gits all th' profits."

In this way, Bates's novel, having been written sometime before 1887, captured the essence of Butte just as it was making the transition from a crude camp to a veritable western city. Only a few years later, when copper replaced silver, Butte would be one of the largest cities in the Northwest, as large as Spokane and in league with Minneapolis, Calgary and Salt Lake City. *A Blind Lead*, among its other merits, may claim the distinction of being the first novel to describe Butte as an established community in the West and, by charting its early changes, helped lay the foundation for the literary persona it would develop.

At the same time, and because of her literary and intellectual background, Bates was philosophical in her treatment of the miner as a character "type." In spite of the loneliness of finding himself hemmed in and isolated by the endless mountain ranges and ranchless valleys, the miner, she wrote, comports himself with a "dogged cheerfulness" at the prospect of striking it rich. Such frontiers become cosmopolitan and egalitarian congresses of "all nations, classes, trades, and characters," where all comers in a sense are possessed of a "spirit which dares…and which makes the laborer of today the capitalist of tomorrow."

Bates thus seemed to embrace the prevailing Gilded Age sense of "pulling oneself up by the bootstraps" that was the hallmark in the fiction of her contemporary Horatio Alger Jr. and other writers who sought to justify the rise of the Gilded Age robber barons as a natural result of inborn talent coupled with hard work. One hesitates to too quickly lump Bates into the same mold as Alger, since the story she tells in *A Blind Lead* is hardly a capitalist morality tale. It clearly ends on a note of tragedy rather than triumph. Nevertheless, having lived in Butte in the mid-1880s, she saw firsthand the possibilities that a mining bonanza presented to a savvy entrepreneur, and no doubt she had in mind the successes of both William A. Clark and Marcus Daly, who each in his way embodied the ideal of the self-made man who arduously made his way up from the bottom to the top of the Butte hill.

Bates also captures some revealing aspects of this period of Butte's social history. Though all of the various businesses of the town she describes

are "wedged in promiscuously" against each other, "first and last and everywhere in unchallenged supremacy is the saloon." Nearly every account of the early mining camps of the 1860s in Montana refers at length to the widespread availability of liquor and gambling in the saloons that clever entrepreneurs erected almost as soon as the first promising shafts were sunk. She also devotes an entire chapter to "the Silverline Club," clearly depicting the exclusive Silver Bow Club, playhouse for Butte's mining magnates and capitalist aristocracy.

Similarly, while the town exudes a sort of frightening unruliness, she's reassured by an accompanying sense of frontier justice: "From mouth to mouth, 3-7-77, the mystic number of the vigilantes passes," she writes, and order is maintained. The cryptic "3-7-77" she mentions is a reference to the vigilante period in Montana history some twenty years earlier, when the early mining camps at Virginia City, Bannack and Helena were plagued by Henry Plummer and his gang of ruthless thieves. In response, otherwise upright and respectable citizens in those communities resorted to the questionable tactic of taking the law into their own hands, and eventually Plummer and dozens of others were hanged. In most cases, the bodies of those suffering such "summary justice" were ominously marked with the numbers "3-7-77," a figure that became known as the vigilantes' calling card. Bates suggests in her description that the atmosphere of Butte in 1887 retained much of that earlier lawlessness, even if the legacy of the vigilantes and memory of their mark was often enough to preserve order. Her description grasps accurately that aspect of the western mining camps and their urge for autonomy and self-rule based on what was loosely called "miner's law." In short, most mining communities, especially if they were particularly remote, soon developed their own versions of justice courts, usually respectable facsimiles of the real thing, with informal hearings and ad hoc trials before peers.

Anyone who has ever seen a map of Montana's ghost towns realizes how quickly mining towns came and went—hundreds of towns with fetching names like Comet and Elkhorn and Garnet that once boasted populations of hundreds of citizens, sometimes thousands, are now nothing more than a handful of weather-beaten storefronts without windows and remnants of wooden walkways. Bates evokes the progression in a few short lines: "The air of transitoriness that grows out of its very nature," she writes, marks the town, with its citizens like "birds of passage" poised to "spread their wings in flight upon the first evidence of decline." Although the time she spent among the mines was relatively brief, Bates rightly perceived that mining camps tend to attract drifters and schemers, dreamers and the shiftless sorts

of men spurred on by rumors of riches who descend on a boomtown with high hopes and loose ties. In a few passages in a few dozen pages, Bates presents readers with a vivid view of what life in a boomtown was like. Butte, of course, grew into a city rather than fading into a ghost town, but at the time that Bates was writing, such an auspicious future would have been unimaginable, given the many examples to the contrary, including the famed Comstock Lode in Nevada, whose fate had been decided by 1880. In fact, Butte defied the odds for decades beyond the typical life expectancy of a mining town.*

Bates matches her ability to capture the spirit of the city with a talent for describing the surrounding landscape. What is especially remarkable in some of these passages is how enduring the images remain. At times her words, published in 1888, might very well have appeared last week in a description of certain Butte neighborhoods of 2014:

> *The early placer workings have left the bed of the valley seamed and torn, and piles of smooth stones lie washed of the soil that imbedded them, which has been swept into the stream, that now creeps sluggishly amid its sandy bars. From the chloridizing mills too, with the dark tailings, has been carried a solution of salt which has left its deposit, a grayish film, along the banks. Westward with even swelling slope looms a huge porphyry butte, a figure solitary and commanding.*

Her characters are vibrant and colorful—she handles the brogue of one family with uncommon facility, and the novel is filled with interesting and odd characters, not the least of whom is the owner of what must be among the first bookshops in Montana, a man consumed by a lust for collecting and trading. Perhaps most striking about her characterization in this novel is that she devotes as much time to the female characters as the male, and in fact, the women in the book seem to possess the real functional power, while the men fall victim to their own follies—whether it is a lust for mineral treasure and the unrewarding drudgery that brings exhaustion and death or, in the case of James Wayburn, an insatiable urge for collecting and trading that leaves him destitute.

The heroine Ellen Wayburn stands out especially. As one would-be paramour explains, "It refreshed him to find a woman who was not

*. Nevertheless, anyone who wanders Butte's uptown streets today can't help but feel that in a very real sense, Butte became something of a ghost city, having dwindled in numbers from 100,000 at its peak to around 30,000 today, leaving behind many abandoned and tumbling-down buildings.

interested in the mines; who was personally unconcerned whether the camp boomed or collapsed tomorrow; who did not look forward to being rich or distinguished, and yet who was not conscious that she was an anomaly...Jerold recognized Ellen's superiority." Ellen explains her own strength of character by way of pragmatism: "People endure in this world because they must," she says, "not because of any principle."

In another scene, her would-be suitor Jerold tries to explain that most miners are bachelors because "women are an incumbrance," especially since "you can't shoulder her, like your pick, for a trip of a few hundred miles into the mountains." Ellen is incensed and retorts with heavy sarcasm, "Heaven deliver us all from a country where women are an incumbrance." Meanwhile, her sister usurps the ineffectual patriarch of the family by taking over his business, turning a liability into an asset and succeeding spectacularly where he had failed.

As a schoolteacher, Ellen Wayburn espouses a surprisingly progressive pedagogy for 1888, articulating ideas that anticipate John Dewey and Maria Montessori by decades. For example, in one expressive passage, Ellen explains to Robert how contemporary education fails its students, using language that will surely find sympathy among educators of the twenty-first century resistant to the "one size fits all" approach often mandated by misguided reformers:

> *Each child is unlike every other, and each looks out upon this big universe with different-toned faculties. The course laid down in schools ministers to what these minds have in common, but gives no growth to what they have individually. Now this individuality, it seems to me, must be the first and the last thought in a true education. His own latent gift must be the child's and the teacher's constant study. But it is ignored entirely, and the child's mind is general held up to him as such a stupid little possession that he is half ashamed of having such an encumbrance at all. He is treated as nothing but an embodied memory. Every energy is spent on absorbing. It is knowledge—knowledge at the expense of power—until individuality is almost entirely lost.*

Through the voice of her character, Bates offers a nice summation of the key principles of progressive education as developed by Francis W. Parker, who started the famous Quincy Method in 1875 (named for Quincy, Massachusetts, where Parker was superintendent of schools). Bates possibly studied Parker in her curriculum at Lake Forest College, known for its progressive approach to liberal education.

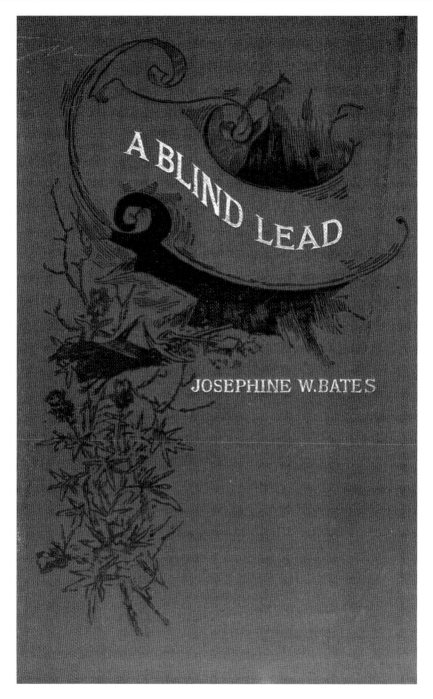

Josephine White Bates's *A Blind Lead: The Story of a Mine* (1888). *Collection of Aaron Parrett.*

And finally, Josephine White Bates anticipates many future Butte novels when she makes reference to the contentious relationship between the mining conglomerates and the prospectors: many of those who never struck a paying lode found themselves compelled to become miners working for someone else. As one character observes, "The rich men own the camp and everyone in it, body and soul." Yet the most philosophical meditation on the "unsuitableness of work" for human beings Bates puts into the mouth of the richest man in town, an odd juxtaposition that drives home the point that the relationship between capital and labor is always more complex than either side would like to make it. It also underscores the fact that, in Butte at least, the acrimonious battles between labor and capital were still nearly twenty years away.

Written in the romantic idiom of the late nineteenth century, *A Blind Lead* stands out from the multitudes of similar novels because of its conceit of mining and its provincial setting. The book is ultimately a romantic tragedy on the model of works such as Theodor Storm's *Immensee* (1849), in which the union of the protagonists remains unconsummated and death alone emerges triumphant. The novel ends with a single spoken word comprising what must be one of the most perfectly fitting double entendres in Montana literature: "Mine."

With its romantic plot set against the backdrop of mining, *A Blind Lead* distinguishes itself from the typical western romance. And beneath the ground its characters inhabit lie the inklings of what will soon lead to legends of "the Richest Hill on Earth." Even if John Howard strikes "a blind lead," in her novel, Bates clearly presents Butte as an emerging phenomenon, and she offers provocative hints of the themes that later writers will develop.

BUTTE IN ITS PRIME

Mary MacLane and Other Early Narratives of Butte

The brilliant sparkling look of the town from far out on the Flat late in the evening, like a mammoth broken tiara of starry diamonds.
—*Mary MacLane*

MARY MACLANE

Chances are good that a century from now, long after literary critics have stopped debating whether A.B. Guthrie or Norman MacLean wrote the great Montana novel, Mary MacLane (1881–1929) will still draw readers to her clutch of odd books: *The Story of Mary MacLane* (1902), *My Friend Annabel Lee* (1903) and *I, Mary MacLane: A Diary of Human Days* (1917). It strains the meaning of the term to call any of these works "novels," but no other descriptor—memoir, prose poem, philosophical meditation—quite captures the brazen novelty of the work MacLane delivered to the world in the first decades of the twentieth century. Her idiom resembles philosophy much more than it does biography or fiction, which has led some to draw comparisons to Nietzsche, and both authors present their ideas in ways that defy convention and easy categorization. Like Nietzsche, MacLane shocked her contemporaries by creating a style of writing that set more precedents than it followed.

In 1882, Nietzsche scandalized Europe when his madman ran into the marketplace and announced the death of God in *The Gay Science*. Mary MacLane

The frontispiece image from the first edition of *The Story of Mary MacLane* (1902). Nineteen-year-old Mary MacLane's unabashed confessions shocked and titillated the country, making MacLane an overnight sensation and one of the early twentieth century's most famous celebrities. Photographer unknown. *Collection of Aaron Parrett.*

did him one better when she tried to title her first book—written at the precocious age of nineteen—*I Await the Devil's Coming*. Naturally, her publishers squelched that idea; very few among even the most freethinking of readers in 1902 could have avoided blushing at the thought of displaying *that* book on their shelves. Herbert S. Stone & Co. published the book, having caused a sensation the year prior by publishing Kate Chopin's *The Awakening* (1901)—another book by a precocious young woman who scandalized a society dominated by male taste.

Instead, MacLane's book appeared in bookstores under the more humble and engaging title of *The Story of Mary MacLane*. It was a bombshell, selling over 100,000 copies within the first few months of its publication, according to the preface of *Tender Darkness*, a recent compilation of her works. America in 1902 remained prudish and pious, and her irreverence and unashamed commentary on her sexual feelings and intellectual inclinations shocked the country and intrigued the rest of the world. The *New York World* hired her to write a series of articles in the wake of her new notoriety, announcing that her book "has been unquestionably the most widely discussed book of the year."

Mary MacLane's life and work have been treated in depth in various articles and in the various prefaces to the reprints of her work, though no

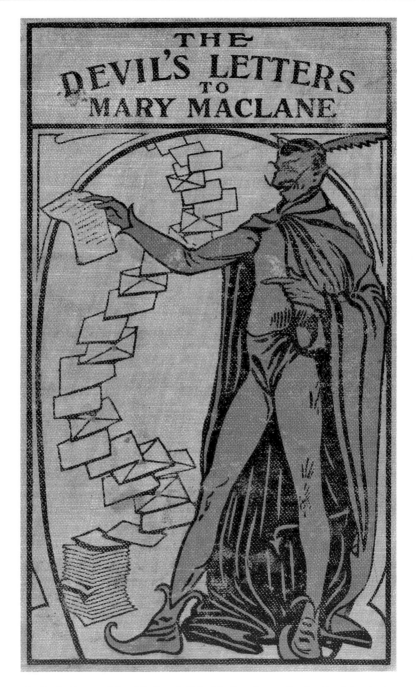

The Devil's Letters to Mary MacLane (1903). MacLane's popular first book inspired many parodies, including this one by Mrs. McKown of Butte (though credited on the title page only to "himself"). *Collection of Aaron Parrett.*

biography or comprehensive literary study of her work has appeared. Her work inspired a number of parodies and replies, including *The Story of Willie Complain*, published in Butte by a young Robert Shores shortly after the appearance of her book in 1902, and the full-length book *The Devil's Letters to Mary MacLane*, by Mrs. T.D. McKown in 1903. The local Butte paper, the *Inter Mountain*, in its August 28, 1902 issue, celebrated the appearance of Shore's seventy-four-page parody as a "triumph of typographical perfection," gloating over its "beautiful burlesque" of "the only literary light we ever had" and clearly taking the side of the critics seeking to disparage Mary MacLane. The fawning review closed on a chauvinist note: "Mr. Shores is to be complimented on his initial effort, which in places falls below the work of the Great Mary in that its author is not of Womankind." H.L. Mencken, on the other hand, who was hardly sympathetic to feminism, acknowledged her genius in several reviews collected in his book *Prejudices* (1919) and delighted in the fact that she scandalized Americans' pious sensibilities with unflinching descriptions of her sexual yearnings.

Mary MacLane's feelings for Butte were ambivalent: on the one hand, she deplored its hideous pollution and austerity, but on the other, she attributed a good part of her own character development to the loneliness and cultural privation she had been forced to endure there. She also extolled the beauty of the surrounding area. In *The Story of Mary MacLane*, for example, she wrote, "Butte and its immediate vicinity present as ugly an outlook as one could wish to see. It is so ugly indeed that it is near the perfection of ugliness. And anything perfect, or nearly so is not to be despised."

Though she wrote these words in 1902, MacLane captured a sense of the place that endures to this day, even if the signature of that ugliness has been transformed from the noxious pallor of sulphur smoke to the less ephemeral gash of the Berkeley Pit. Other literary voices soon chimed in: the logorrheic Elbert Hubbard echoed MacLane a year later in his *Philistine: A Periodical of Protest* that Butte was "the ugliest city on earth," and historian Carroll Van West cites a postcard sent by Will Rogers in 1908 when he visited Butte, containing this message: "Beautiful Scenery. There aint a tree in 10 miles."

In 1907, Helen Fitzgerald Sanders, famous for writing one of the early histories of Montana, tried to soften the harsh view of Butte's ugliness with an article in the *Craftsman* called "Redeeming the Ugliest Town on Earth," but even she had to admit that the town at night resembled Dante's inferno; although by daylight, she wrote, the city "bore a startling likeness…to the outlying regions of Purgatory." Sanders no doubt recalled both MacLane's passage in *The Story of Mary MacLane* from five years earlier and the echo of

Hubbard. In the cultural geography of the West, Butte, Montana, staked out early on an enduring and peculiar identity, part of which consists in an unabashed pride in its undeniable ugliness. And while Butte has always lent itself to that impulse of characterization that more often is reserved for the big cities, such as New York or Paris—urban centers that become embodied and endowed with a distinct soul and personality—ugliness often becomes Butte's signature quality. As a bestselling author with an incredibly broad audience for 1902, Mary MacLane probably did more than any other writer to establish that idea in the public mind.

MacLane helped develop the literary personality of Butte in other ways. She neatly documented the temper and mettle of its various ethnic groups; the busy, bustling throngs crowding its avenues on any given day; and the haunting evidence around her of industrial blight. At the same time, she cast her observations against the backdrop of a more literary than historical purpose: as "a philosopher of my own peripatetic school," she wrote, "hour after hour I walk over the desolate sand and dreariness among tiny hills and gulches on the outskirts of this mining town." The barren landscape matched her desolate mood and what she called "the pageant of my unparalleled egotism," an honest if enigmatic phrase.

Many modern readers find her relentless references to her own genius both tedious and pretentious, but she seemed aware of the impulse and balanced it with revelations of what she acknowledged as her flaws. So, too, she revealed intimate details about herself that most people even today would hesitate to divulge in a published book. "The Devil has given me some good things," she wrote irreverently, "for I find that the Devil owns and rules the earth and all that therein is." In passages that horrified many readers in 1902, her blasphemy overlapped with her libido: for example, she wrote that "He [the devil] has given me, among other things—my admirable young woman's-body, which I enjoy thoroughly and of which I am passionately fond." In later paragraphs, she confessed an unashamed Sapphic love for her teacher Fanny Corbin, a revelation that certainly shocked her neighbors in Butte and nonplussed the nation. She thanked the devil for having given her two good legs and a "short skirt," since they afforded her the opportunity to hike out of Butte into the hills north of town, where "the young poplar trees smile gently in the deathly still air" and "the sage brush and the tall grass take on a radiant quietness [and] the high hills of Montana, near and distant, appear tender and benign."

Few passages in Montana literature can rival the quiet elegance of that one or so deftly capture the splendor of the outskirts of Butte at twilight.

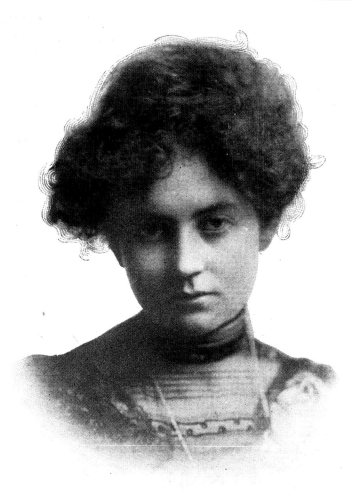

The frontispiece image from *My Friend Annabel Lee* (1903). MacLane's second book was less successful but perhaps more quirky and unusual than her first. Photographer unknown. *Collection of Aaron Parrett.*

Poised between the industrial nightmare of mining pollution and the solitude of her lonely wanderings outside town, it's no wonder that Mary MacLane imagined the Devil as her savior—Butte was a kind of visible hell, but she felt herself full of promise, and everything beyond Butte beckoned invitingly. She longed for fame, for adventure, for what she tried to summarize as "happiness," the taste of which eluded her in Butte—even if she expressed gratefulness for the ugliness and privation for having engendered her desire.

For several years, Mary MacLane enjoyed her status as a cause célèbre, circulating among the artists and literati of New York City. Her descent from the heights was as meteoric as her rise, and in 1910, she found herself back in Butte, where she wrote columns for the *Butte Evening News*, occasionally publishing essays in magazines. One *Butte Evening News* article, called "The Second *Story of Mary MacLane*" (January 23, 1910), helped solidify her intimate association with the place, ensuring that she would ever after be its preeminent "bad girl."

Her later essays in many ways outshine the quality and style of her early books since they reveal a more mellow and measured mind at work. They also reveal a matured reverence for Butte and further expostulation of its character: "Seven years ago, I left this weird little town," she wrote. "Butte now looks upon me as a returned and limelighted prodigal, a woman with a past, and an insolent young jade withal." But she had grown to love Butte nonetheless, telling her readers that "I have none but a joyous hand for it. Butte is sordid, beastly and time-serving—but withal full of romance and poetry and the wideness for the West." For that matter, seven years in New York and eastern environs had given her a new perspective on a place one might call home. "[Butte] is fascinating and picturesque, which is all I ask of anything," she declared. "Morals are nothing but boresome trifles, and art is too often like a nightgown on a hot August night by the sea—superfluous." Her ultimate gesture was to offer thanks to Butte: "A certain deadly thrall hangs over this little place, which impregnates one's mind, if one happens to possess one—they're rare—and brings to it a reckoning and an accouchement." Seven years had opened her young eyes to "the pomps and vanities of this wicked world," as she put it in another essay, but she had never lost her "genius." For her "black-and-white brilliance," she said, "I thank Butte."

In another gesture critical of the character of Butte, MacLane indicted the city for its bad taste and busybody women. Gertrude Atherton, later recalling time she spent in Butte doing research for *Perch of the Devil*, mentioned a visit with Mary MacLane, whose writing she praised as "startlingly audacious" and "containing something very close to a real philosophy of life," both comments that reveal a marked contrast to her reactionary male critics. Atherton also delighted in relating what happened when the women of Butte's upper crust, who had earlier excoriated Mary MacLane behind her back for having written *The Story of Mary MacLane* and having heaped scandal on Butte, fell all over themselves inviting her to parties after her triumphant return to Butte, a now-famous woman and a literary success. "They surrounded her, flattered her, quoted from her book,"

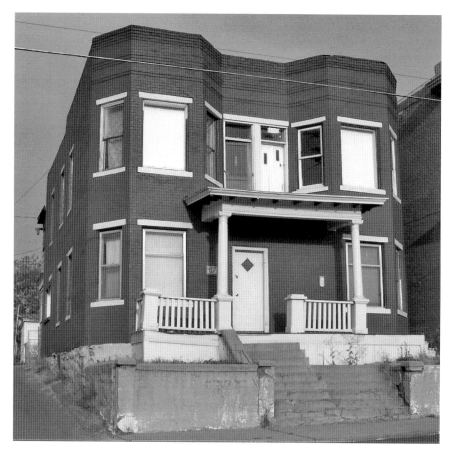

A photograph of the house in which Mary MacLane grew up in Butte (417–419 North Excelsior). According to MacLane scholar Michael Brown, the room in which she wrote *The Story of Mary MacLane* is the upper right. Richard Gibson photograph. *Courtesy of Richard Gibson.*

writes Atherton. But MacLane saw through their blandishments: "She sat in silence, smoking, her large brown eyes roving sardonically from one face to another. Finally, she arose, tossed her cigarette stub on to the Aubusson carpet, and remarked, 'Do you know what you all remind me of, you fat rich women? A lot of hogs with your feet in a trough.'"

Like Nietzsche and Marie Bashkirtseff, Mary MacLane was not long for this world. She seemed prescient of her fate, writing in 1910 these words: "The thing I took away with me from Butte seven years ago—a restlessness of spirit, a shadowed and turbulent mentality, a lack of inward peace—is the one thing I've brought back with me, and which will follow me to what I trust will be a young grave."

A still from the motion picture *Men Who Have Made Love to Me* (1917), starring Mary MacLane as herself. No copies of the film are known to exist. *Courtesy of the U.S. Library of Congress.*

She published three books in her lifetime, the last in 1917, the same year that she added more scandal to her resume when she starred in a film called *Men Who Have Made Love to Me.* The film was a full-length feature over ninety minutes in length, but sadly, no copies are known to exist. Scholars have discovered a few stills from the film that capture some of the best available images of Mary MacLane, and several reviews of the film are listed in the bibliography of *Tender Darkness.*

Neither the film nor any of the other books she published matched the success of *The Story of Mary MacLane.* When she died in 1929, broke and mostly forgotten in a Chicago hotel room, her books were out of print.

WILLIS GEORGE EMERSON

In stark contrast to the unconventional and risqué work of Mary MacLane, most of the popular novels that appeared around the same time set in Butte were staid westerns. Two of these are worthy of note, mainly because of their author's connection to Butte in the context of real estate fraud. Both novels are romantic westerns set against the backdrop of mining in Montana and Idaho, with "Butte City" playing a central role. The first of these is *Gray Rocks: A Tale of the Middle West* (1894); the other is *The Builders* (1906), both penned by Willis George Emerson (1856–1918), an odious conniver who presented himself throughout the West as a respectable businessman and legitimate politician.

Emerson might very well have risen to the status of robber baron, since he possessed a keen instinct for chicanery; he seems to have been prevented by a shortage of the additional good luck required. Emerson traveled throughout the West in pursuit of wealth and political prominence. He was a "well-known leader of the Republican party," according to a writer in Chicago, and a "gifted

George Willis Emerson. *Courtesy of California Digital Newspaper Collection, Center for Bibliographic Studies and Research, University of California, Riverside, cdnc.ucr.edu.*

Los Angeles Orator," according to another in California. Emerson amassed a fortune in real estate in Montana, Wyoming and California, although both his Montana and Wyoming developments were exposed as frauds. Emerson became known as a "town builder," although an editorial review of his *Gray Rocks* in the *Anaconda Standard* expressed a sharper view of the writer as a charlatan and con artist. The *Standard* also took a dim view of his literary prospects: "We judge from the preface that it is his first novel, and from the same source we learn with some alarm that there is no certainty that it is to be his last."

Emerson's novels are unusual on several counts: he refers to Butte by its original name of Butte City, for one; the miners seek gold, rather

Willis George Emerson alienated citizens of Butte and Anaconda through real estate fraud. He later commemorated his chicanery in two novels about Butte. *From the* Anaconda Standard, *October 26, 1890.*

than silver or copper, for another—though this is clearly an anachronism. *Gray Rocks* seems very much a practice run for *The Builders*, since it is narratively and stylistically weaker, and whole scenes and sections of dialogue are plagiarized from *Gray Rocks* and incorporated into *The Builders*.

Poetic license in both novels tends to overshadow historical reality; in both books, Emerson depicts Butte as a city of fifty thousand people whose main industry is gold mining, but Butte's population only swelled to such proportions when copper received primary focus. The protagonist of *The Builders*, Fred Rockwell, is skeptical of the place at first but soon realizes that "it was a town without a prototype." One of the prominent citizens of Butte City in *Gray Rocks*, Hank Casey, proclaims that "we have lots of towns in this 'ere state, sech as they be; lots of minin' camps, but they're merely blacksmith-shops-at-the-crossroads compared to Butte City"—a speech that is lifted verbatim and put in the mouth of a similar character in *The Builders*.

Emerson, like many other Butte novelists, presents an accurate, if grim, picture of the oppressive pollution that plagued Butte. When someone from "down-east" arrives in town and begins to complain about the horrid pall of sulfurous haze, one of the inhabitants defends the town in *The Builders*: "Let me tell you, if we didn't have this 'ere smoke we wouldn't have any Butte

City, and, besides, it kills the bacteria, microbes, and all that sort of thing. It's mighty healthy here, I can tell you, and a mighty pert town in the bargain." The notion that the pollution in Butte somehow carried antiseptic power endured at least into the 1920s, when Berton Braley wrote his Butte fiction, since he also championed the salutary effects of the smoke.

The title was doubtless inspired by the Gray Rock mines in Butte (northeast of Centerville), which, according to the *Anaconda Standard*, were among the "most productive of the Butte & Boston properties." Both of Emerson's novels divide their time between Butte City and mining regions in Idaho, matching the real-life experiences of their author. Interestingly, Emerson practically incriminates himself as a real estate con artist, giving names to locations in the books as "Gold Bluff" and "Thief River Valley," while snidely defending the practice of selling worthless land to unsuspecting victims on the grounds of *caveat emptor*. One character insists in *Gray Rocks* that the land really is valuable—its "worthlessness" is merely the failure of industrious men to develop it, a refrain similarly invoked by white settlers throughout the West as they seized Indian lands.

HARRY LEON WILSON AND RIDGWELL CULLUM

The Spenders (1902), by Harry Leon Wilson (1867–1939), can't quite be called a Butte novel, although the parts of the book that take place in "Montana City" surely refer to Butte, given the preeminence of copper barons and mining. The novel deals more directly with the lives of its characters in New York. This is an aspect of Butte history that Montanans tend to forget or ignore: almost all of the vast mineral wealth of the Butte hill ended up back east in the pockets of capitalist investors in Boston and New York City. Wilson's book is worth mentioning because although it is not primarily set in Butte, it does illustrate how very few of the principal developers of the Butte hill kept the vast wealth they pulled from the hill in the local or even state economy.

Harry Leon Wilson was most well known for his *Ruggles of Redgap* (1915), which was made into a blockbuster film in 1935. *The Spenders* (1902) offers a compelling contrast to Bates's *A Blind Lead*, which presents the early days of Butte's development from the perspective of the "small" people; *The Spenders* presents the attitudes and exploits of wealthy easterners who vacation in Butte and speculate on its Wall Street offerings but have little to do with life in the West.

The frontispiece for Ridgwell Cullum's *The Sheriff of Dyke Hole* (1909). Artist: The Kinneys. *Collection of Aaron Parrett.*

Ridgwell Cullum's *The Sheriff of Dyke Hole* (1909) takes place in the regions around Butte and involves a leading English character who happens to inherit a mine in Montana. While Anaconda is mentioned by name, the city of Dyke Hole appears to stand for one of the smaller towns outside Butte, possibly Rocker or Deer Lodge, since Butte (spelled "Bute") appears in its own right. In any case, the genre did not call for a strict fidelity to geography, and Cullum, like many of his colleagues, adapted actual names and places to suit his purpose, which presented romance and adventure convened against a western backdrop.

Ridgwell Cullum was the pseudonym of the British adventurer Sidney Groves Burghard (1867–1943), who immigrated to Montana to become a cattle rancher in the early twentieth century. He turned to fiction writing in 1903, publishing *The Devil's Keg*, which was an immediate bestseller and confirmed him in his new profession.

The *Sheriff of Dyke Hole* is essentially a western with a mine as the center of action rather than a ranch and may be distinguished from other examples of its genre only by such incongruous and unlikely features as a sheriff who regularly "takes tea" and the fantastic conception of every small town in southwestern Montana fielding a cricket team. *The Sheriff of Dyke Hole* remains a peripheral Butte novel but a quirky romp nevertheless. The book warrants a glance a century later, if only for the reason that some of its more zany elements presage some of the twenty-first-century novels considered in Chapter 6.

Another of Cullum's novels, *The Golden Woman: A Story of the Montana Hills* (1913), was also a romantic western involving an inherited mine, this time near the curiously named town of Leeson Butte. The earliest history of Montana was published in 1885 by Michael A. Leeson, which makes one wonder whether Cullum simply welded the last name of Montana's first historian to the name of Montana's most famous city.

While Cullum uses mining as a vehicle for this novel as well, the genre in both cases is clearly the western, and so rather than setting his two quasi-Butte novels in town, he situates the mines outside town to preserve the wilderness setting. The actual mine is called Devil's Hill, no doubt a veiled reference to "perch of the devil"—a term dating back at least to 1898.

The Golden Woman contains some compelling descriptions of the early days of a mining camp:

> *The flaying picks rising and falling amongst the looser debris, the grinding scrape of the shovel, turning again and again the heavy red*

gravel. The shouts of hoarse voices hailing each other in jubilant tones, voices thrilling with a note of hope such as they had not known for weeks. He saw the hard muscles of sunburnt arms standing out rope-like with the terrific labor they were engaged in. And in the background of it all, he saw the grim spectacle of the blackened hill, frowning down like some evil monster, watching the vermin life eating into a sore it was powerless to protect.

The Golden Woman climaxes with an earthquake and flood during which the face of the mining camp is erased and scoured away when a nearly boiling lake of water behind the mine is unleashed.*

Further evidence that "Devil's hill" refers to the Butte hill may be seen in the comment of leading lady Joan Stanmore, who, when she first sees the mining activity organized on the steep slopes, finds herself "held by the hypnotic stare of a python"—a veiled reference to the Anaconda Company. Later, her cryptic verdict applies with even greater force to the Butte of the modern era: "It's a weird place, where one might well expect weird happenings."

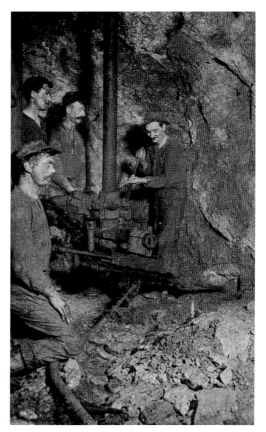

Miners in Butte, circa 1910. Photographer unknown. *Collection of Lyle Williams.*

*. Cullum anticipates a modern and not irrational concern over the consequences to Butte should the Yankee Doodle impoundment dam just to the north of the Berkeley Pit ever fail.

GERTRUDE ATHERTON

Another novel completely devoted to Butte does not again appear on the scene until five years after Cullum's *The Sheriff of Dyke Hole*, with the publication of Gertrude Atherton's *Perch of The Devil* (1914). Atherton (1857–1948) was among the most successful writers of the early twentieth century, a protégée of Ambrose Bierce and a *grand dame* of literature. She penned over thirty novels, many of which were bestsellers in her lifetime. By the time she wrote *Perch of the Devil*, Atherton had published seventeen novels.

Perch of the Devil might be the most widely read of the Butte novels of this period, if one can judge from the number of copies of the book still extant in comparison to the others of this era. The Montana historian Richard Roeder considered it "a remarkable book," though few modern readers would concur: her prose tends toward tedium, infused throughout with an affectation of intellectual self-consciousness that often congeals the narrative. Page after page, one finds examples like this:

> But this clever girl of the people, who might before many years had passed
> be one of the rich and conspicuous women of the United States, above all,
> the wife of one of the nation's "big men," working himself beyond human
> capacity, harassed, needing not only physical comfort at home, but counsel,
> companionship, perfect understanding,—might it not be her destiny to equip
> Ida Compton for her double part?

In her book *Adventures of a Novelist* (1932), Gertrude Atherton tells the story of how she wrote *Perch of the Devil*. Having "written enough about Europe," she says, "I conceived the idea of laying the scene of a novel in one of the little exploited North-Western states." Conversations with those in her literary circle led her to choose Montana, and specifically Butte, since, owing to its "copper mines and spectacular personalities," it was "almost as famous as California." After a brief visit to Butte for inspiration, she wrote the first chapters of the book in Genoa, Italy. She soon realized her descriptions of mining would suffer without firsthand material to draw from, so she made plans to return to Montana. She therefore spent another month in Butte, absorbing the "noisy, bustling, swarming, ugly, but highly interesting city." Like many writers before and after her, Atherton conceded that Butte "has more personality than any town of its size in the United States." Ironically, she found actually writing in Butte impossible because of the unceasing noise of the streets.

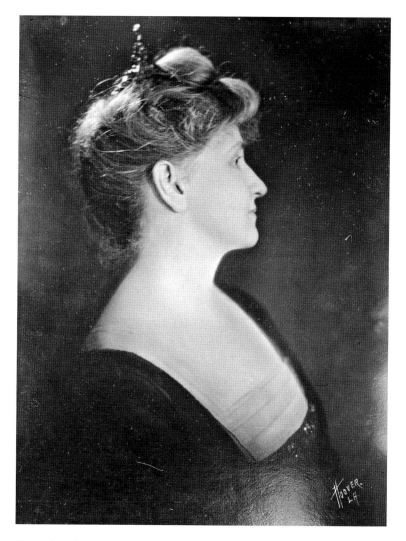

Gertrude Atherton wrote seventeen novels, most of them set in Europe, before shifting her attention to Butte with *Perch of the Devil* (1914). *Courtesy of the U.S. Library of Congress.*

Nevertheless, she did her research, even arranging for a descent into the mines in a cage half a mile below the surface ("this gave me a very queer feeling in my legs," she confesses). Not surprisingly, she found the conditions underground every bit as oppressive as she expected: "I wondered how the miners could endure it," she states simply, and the signs everywhere counseling "SAVE YOURSELF" in bold letters "added nothing to one's

A postcard image of hard-rock miners in Butte, circa 1910. Photographer unknown.
Collection of Lyle Williams.

mental comfort." If the streets above were distracting in the unceasing bustle, below ground was even worse: the constant drone of the dynamos, the blasting of dynamite and the frantic activity of men and machines in the narrow passageways was overwhelming. "Never before or since have I been so glad to see the light of day," she wrote in conclusion.

Atherton lived mostly in Helena, Montana, while she worked on *Perch of the Devil* (the dedication page lists her debt to Frank J. Edwards and Wilton G. Brown, prominent citizens of the town), though she spent a month in Butte, where she was "called on" by Mary MacLane, the details of which are catalogued in her *Adventures of a Novelist*. According to Atherton critic Charlotte McLure, Atherton's *Perch of the Devil* marked a shift in her literary career from writing books about well-heeled eastern aristocrats and their contempt for the bourgeois America they inhabited to books about the cultural promise of America, especially the emerging West. Accordingly, after spending a decade in Europe after the fin de siècle, according to Charlotte McLure, "she chose Montana as the setting in which to show a confrontation between the European aristocratic type of

woman and the evolving middle-class woman of the West in *Perch of the Devil*." Atherton remarked later that the Brown and Edwards families "were the only persons in all Montana who did not hate *Perch of the Devil*," a result Atherton attributed to the fact that "no state can stand the truth about itself."

Although the novel sold well, Atherton concluded that it would have done better had it not been released by her publisher just as world war broke out in August 1914. In Montana, the critics were harsh, but everyone seemed to buy the book anyway, and according to historian Leslie Wheeler, local libraries could not keep copies on their shelves.

Pulitzer Prize–winning critic Reuben Maury smelled the rank odor of hypocrisy in the heaps of condemnation leveled against Atherton and her book by her contemporaries, noting that "a thunderous outcry arose from Butte's upper social stratum when the book appeared, to the effect that Mrs. Atherton had misrepresented local conditions shockingly." But because the central character humiliated the "Anaconda Copper Mining Company in a projected land-grab," the book should have pleased the people of Butte, as "an achievement of this generic aspect represents the unspoken wish, or libido, of fully nine-tenths of Montana's male population of voting age." The other 10 percent, he noted, hoped "someday to work for the company." Maury also praised Atherton's images of the Butte hill at night: "She described with much detail and no little artistry the Butte hill at night, with its blazing scarf of lights twirled out against a sky of black ice, the Flat and its roadhouses, the electric atmosphere, the glistering mountains roundabout." Atherton's prose shines in those moments when she depicts Butte as a vibrant city, which brings at least the town, if not her characters, alive.

An image of Butte looking east from School of Mines, 1914. Photographer unknown. *Collection of Lyle Williams.*

Perch of The Devil dust jacket (1914). Artist unknown. *Collection of Aaron Parrett.*

Atherton approaches what John Ruskin called the pathetic fallacy, so thoroughly does she assign a personality to turn-of-the-century Butte. In fact, she personifies the entire state: "Montana, her long winter face a reflection of the beautiful dead face of the moon, bore within her arid body illimitable treasure, yielding it from time to time to the more ardent and adventurous of her lovers." While her narrative style in most respects belongs to the nineteenth century, her depiction of Butte as a living personality helped set the stage for virtually every writer after her to do the same. "Since the smelters have gone to Anaconda," Atherton notes in one revealing passage, "patches of green, of a sad and timid tenderness, like the smile of a child too long neglected, have appeared."

Atherton acknowledges the inherent ugliness of Butte but, like many after her, offers a corresponding defense: "If Butte is the ugliest city in the United States, she knows how to make amends," she writes. "She has the jubilant expression of one who coins the very air, the thin, sparkling, nervous air, into shining dollars, and confident in the inexhaustible riches beneath her feet, knows that she shall go on coining them forever." Atherton marvels at Butte's vivacity in spite of its ugliness, for even if Butte is "uncompromisingly ugly," she writes, "her compensation is akin to that of many an heiress: she never forgets that she is the richest hill in the world." Atherton thrust Butte onto the world stage as she described a thriving, cosmopolitan and nearly European city in spite of the fact that "she has her pestilential politicians, her grafters and crooks, and is so tyrannically unionized that the workingman groans under the yoke of his brother."

Perch of the Devil is the first of the Butte novels to overtly take on the drama of the Clark-Daly feud and the arrival of Heinze as the basis for its plot, and presaging the treatment that many later writers will give the Anaconda Copper Mining Company, Atherton demonizes its predecessor, the Amalgamated Company. The romantic triangle between Ora Blake and Ida and Gregory Compton generates tension that parallels the financial finagling of the copper barons, and the knife fight between the two women deep in the depth of Gregory's mine, as Wheeler noted, "echoes the underground fights between rival groups of miners." Gregory Compton is a loose characterization of Augustus Heinze, while Ora Blake's father—a wealthy capitalist—seems to embody William A. Clark, of whom Atherton was elsewhere highly critical.

CHARLES CLEVELAND COHAN

Five years after *Perch of the Devil*, Butte native Charles Cleveland Cohan (né Cohen, 1884–1969) published *Born of the Crucible* (1919). This moderately enjoyable novel of the heyday of Butte focuses mainly on the labor struggles going on behind the unprecedented development of the mining industry in the wake of electrification and other technological advances. Cohan, who was a journalist, is mainly remembered for his lyrical contribution to the song "Montana," written in a few hours one afternoon in 1910, which became the official Montana State Song in 1945.

In the *Montana American*, editor Byron Cooney wrote four columns of a gushing review of *Born of the Crucible*, reporting that the novel had "universal interest" beyond just the town of Butte where it was set. "Contrary to a pre-conceived notion," he wrote, "the tale is not a labor-war story nor does it suggest propaganda calculated to throw confusion into the ranks of the Wobblies or shatter the Utopian dreams of the curbstone or parlor socialist." Cooney praised the author's mastery of character development and his realistic depiction of Butte and the mining life, pointing out that "the story would lend itself well either to the stage or the movies," at which point he digresses to indict the piracy endemic in the film industry: "It is the rule rather than the exception for authors to pay half a dollar to see their own work five-reeled and garbled only to an extent which will place the production and the studio plagiarist out of the reach of the courts."

Cohan offers an interesting perception of socialism and

Charles Cohan, author of *Born of the Crucible* and the Montana State Song, "Montana." Unidentified photographer. *Courtesy of Montana Historical Society Research Center Photograph Archives, Helena, Montana.*

A neighborhood in uptown Butte, circa 1915. Photographer unknown. *Collection of Lyle Williams.*

socialists by refusing to simply paint the capitalists as insensitive pigs and the laborers as saintly martyrs. The main capitalist here, DeWitt Norton, is himself a veteran of hard work (á la Marcus Daly) who is ever conscious of safety in his mines and the living conditions of his workers; the cool-headed socialist hero, meanwhile, does not go in for the Molotov cocktail or fervid demagoguery, though others of his rivals for leadership in the movement, known as the "Direct Actionists," do. Eventually, Direct Actionist thugs attack and brutally beat the hero Dan Bradshaw, ultimately throwing him in a boxcar and forcibly evicting him from Butte. He regains consciousness, works as a farmhand until he acquires enough capital to buy his own mining operation a few miles from the Butte hill and returns to strike a bargain with DeWitt Norton, effecting monopolization of the hill and taking vengeance on his enemies and winning the girl along the way. The novel is interesting for its lyrical descriptions of the Butte hill and its surroundings, though in his social commentary and economic message Cohan often seems as foolish as Ayn Rand. The novel is primarily a romance, with a sort of Horatio Alger indictment of the labor movement as a class of lazy men and latent criminals.

The novel employs the usual slate of stock characters: the aristocratic capitalist, the noble journalist, the scoundrel and the fair damsel circulating through the interconnecting paths of all these men. Based on his close reading of the novel and his familiarity with Butte, Cooney was able to locate the main character's boardinghouse as presumably modeled after one of the actual Dublin Gulch boardinghouses: Duggan's, Nevin's or Si Simond's. Carty's Saloon, where much of the plot unfolds, Cooney identifies "by geographical inference" as having been surely inspired by taverns where true-life Butte legends such as "Phileen Sullivan or Paddy the Nig once dished out their Shawn O'Lavells* to a thirsty multitude." Cooney admits to a probable bias borne of "long acquaintance and contemporary association with the author" but remarks on the novel with candor: "The author does not indulge in a plethora of 'fine writing,' nor bore with philosophical deductions."

BERTON BRALEY

By far the most readable of the novels of the early twentieth century is Berton Braley's novel *The Sheriff of Silver Bow* (1921). Remembered today mainly as one of America's most popular and widely published poets of his day, Braley (1882–1966) also wrote another Butte novel, *Shoestring* (1931), as well as a captivating memoir, *Pegasus Pulls a Hack* (1934), which contains a lengthy section on his years in Butte, including an account of how he came to write his two Butte novels. Braley worked as a newspaperman in Butte between 1905 and 1909, first at the *Butte Daily Inter Mountain* (1905–6) and then at the *Butte Evening News* (1906–9).

Of the many writers who opened their arms to Butte over the years, none fell so in love with the place as Berton Braley. Where other writers—even those who profess to love Butte—express ambivalence or disdain for its pollution or ugliness, Braley exclaims his affection: "Bleak, gaunt and ugly to the unaffectionate eye; a camp on a scarred and barren hill, surrounded by more barren hills and nearly desolate flats that stretched away to bald and ragged peaks, Butte came in an astonishingly short time to look beautiful to me." While his contemporary Elbert Hubbard disrespected Butte as "the ugliest city in the world" for its slapdash shanties, defoliated hills and choking air, Braley took a more sanguine view:

*. The drink is better known as a Shawn O'Farrell.

Berton Braley and his wife (undated, circa 1930). Braley was among the best known and loved poets in America in his prime, and while he was learning his chops as a reporter for the *Butte Inter Mountain*, he was known to publish the police blotters in rhyming verse. Photographer unknown. *Courtesy of the U.S. Library of Congress.*

[Y]ou ceased to be aware of its ugliness and instead found a certain strange loveliness in its raw colors and rough contours. Slag heaps and ore dumps, weathered with wind and rain and sun into heaps of pigment—sienna, flame, jade, crimson, turquoise, and hot gold. Mine hoists metamorphosed into tall spires of industry, delicate against the bright blue sky. Trestles and

even smelter chimneys changed into cubistic designs that somehow fitted into the terrain and its mighty activities.

More than a half century later, the writer Edwin Dobb, who grew up in Butte, expressed an analogous nostalgia for the slag heaps, noting in an essay that for him, as much as the scent of sage and pine, "the sharp smell of mine dumps" always reminded him he was home. Even more astonishing is Braley's blithe embrace of the suffocating smoke and foul air from the smelters. "After all," he wrote, "it fumigated the town, and there wasn't any infectious disease, and most of us were young and healthy anyway, so what the heck!"

Braley presents the city of Butte as a character personified much as Atherton did. Early in the *Sheriff of Silver Bow*, as protagonist Mike Parks rides a train in from Billings, he offers a vivid description of Butte, circa 1910: "A cup-shaped valley with a rim of barren heights and at one end rose a hill, jeweled and sparkling with thousands of lights, which swept up in a crescendo of brilliancies so that one could not know where the lights ended and the stars began." While the character Parks marvels at the prospect of the biggest city between Minneapolis and Spokane, the titular sheriff of Silver Bow offers his endorsement, offering further evidence of the tendency for novelists to personify Butte as a character: "There she is—Butte. Boy, you'll like her. If you've got red blood in your veins, you'll like her. She's big and she's busy and she's all-fired independent, but she's crammed with good folks and she has a heart as big as a roasting furnace."

In spite of the "tawdry, glaring, roaring huddle of shacks and cribs and scarlet lighted houses that was Butte's shame to the decent," Parks observes a "redeeming quality in it all"—that is to say, a "sheer vigorous frankness about even the vices of Butte that seemed almost healthy in this atmosphere of unhealthiness." Butte's famous red-light district displays a "badness that came not from weariness and over-sophistication, but from the superabundant energy of a town that worked and roistered at top-speed." This last was probably an echo of Atherton's famous remark that "Butte packs every hour into forty minutes."

In other words, for all its scrofulous and drunken exuberance, Butte was no decadent Babylon; the atmosphere might have reeked of sulphur but not miasma. "It wasn't pretty," Parks observes, "it was evil, but the evil was Rabelaisian and rampant, not subdued and cloying." Braley's book also challenges the misconception of the average miner as uneducated and practically illiterate. Many of the "muckers" were called collegiates or

The dust wrapper for *The Sheriff of Silver Bow* (1921). Many Butte novels were presented as conventional westerns, their covers or jackets displaying stereotypical images of western fare, even if their subject matter was mining rather than ranching. Artist unknown. *Collection of Aaron Parrett*.

gentlemen muckers—college graduates looking for hands-on experience to aid them in their quest for engineering jobs. "The mines are crummy with them [collegiates]. A census of the underground workings of Butte would be like a college alumni directory." No doubt Braley's character overstates the case, although several later novels, such as MacCuish's *Do Not Go Gentle*, also feature well-educated and highly intellectual miners.

The sheriff of Silver Bow himself, William Broderick, explains the high crime rate and apparent lawlessness of Butte thus: "The old Wild West is dead—or pretty nearly dead—but there's a lot of its spirit still surviving. And that's what we're dealing with here. It's more sophisticated, smoother, more subtle, but it still exists. What we're up against now is the Wild West outlaw crowd with its old-time reckless courage changed to cautious and insidious corruption, organized on business methods." Braley lived in Butte just as the pioneer days were ending, before the ascendancy of the Amalgamated (soon to become the Anaconda) syndicate. In *Pegasus Pulls a Hack*, Braley recalled those years fondly: "The Big Company's shadow was not yet long enough or black enough but so you could step out of it into the sunshine. Heinze was to depart forever a few years later and the fiercest of his fights were finished, but he had helped to preserve the pioneer spirit, and the Miner's Union was still a power."

At the same time, the book contrasts the liveliness of Butte with its more sedate counterparts in other regions of the state: "Nobody thinks of killin' anybody in Billings because they know the town is dead already," remarks one character wryly. In this sense, Butte resembled something of a miniaturized New York, ghettoized into neighborhoods by language or nationality—Finntown, Chinatown, Dublin Gulch, etc.—although one advantage the smaller town enjoyed over its gargantuan cousin was that "in New York, nobody knows what you are doing and nobody cares, in Butte everybody knows what you're doing and nobody cares."

Parks's love interest, Celia Broderick, the daughter of the sheriff, remarks, "I'm fond of Butte, but sometimes—sometimes it's an awfully tough town." Celia embodies the quintessential qualities of what in a few years will be called a flapper—a young woman willing to flout convention and make her own way in the world. "They say that the West is a land of individualists," Celia says, "and I'm a true daughter of the West." Women wrote a significant number of the novels about Butte, but the city inspired many male writers to compose fiercely independent and capable female characters in their novels as well.

In the course of the story, our heroes battle it out with the forces of evil beneath the streets of Butte, scampering through abandoned mine shafts

The corner of Park and Main Streets in uptown Butte, 1922. Photographer unknown. *Courtesy of Bill Nettles.*

and tunnels, scurrying through working mines and secret passageways into shacks in the "Hophead Colony." One gets the feeling that like Rome or Paris, Butte is an old city riddled with its own version of catacombs. Before the Berkeley Pit carved out a significant portion of the hill, engineers estimated the Butte hill was perforated with nearly ten thousand miles of shafts and tunnels.

As with many of the novels that treat this period of Butte's history, the plot centers on the celebrated Apex law, a curious feature of the 1872 Mining Law that Augustus Heinze exploited to unprecedented advantage. While Heinze's genius for exploiting the law is indisputable, critics point out that he depended as much on his ability to manipulate witnesses and judges quite outside legal bounds.

In his other Butte novel, *Shoestring* (1931), Braley even more clearly bases his protagonist on the figure of Heinze, embattled against the Consolidated Mining Corporation, a thinly disguised Amalgamated. Butte appears here as a city called Maverick, though the detailed descriptions of the landscape

and surroundings make it clear we are in Butte: "An ugly town, a raw town, a hard-living, hard-fighting, hard-drinking town; but also a gallant, gay, careless, and tonic town." Though critical scenes of violence occur underground, the novel's characters spend more time in court than fighting in the mines, which mirrors history: Heinze wreaked more havoc by way of the mining laws than he did hijacking his adversaries' mineshafts.

Shoestring lacks the sustained focus and central mystery of *The Sheriff of Silver Bow*, and its sprawling ambition obscures its purpose. The novel is as much a novel about poker as it is about mining, though Braley clearly intends to show the kinship between gambling and financial speculation. The novel concludes for Randall similarly to the way real life concluded for Heinze: Randall's victory over the Consolidated is as fleeting as Heinze's defeat of the Amalgamated, and both subsequently lost everything in trying to outwit monopolists on Wall Street.

In both of Braley's books as well as in Clyde Murphy's *The Glittering Hill* (considered in the next chapter), Augustus Heinze performs with as few scruples as the corporations against which he so audaciously did battle, but at the same time, these novels portray him as a hero for the working classes. Heinze cemented his popularity among the miners of Butte by freely offering unparalleled benefits, increased wages and what had long been the Holy Grail of organized labor: the eight-hour workday. Consequently, his transparent attempt to gain control of the hill by outright fraud and theft was championed by those who resented the years of company abuse. Heinze succeeded at what many others had secretly dreamed of: bringing the conglomeration of mining interests controlling Butte to its knees.

Braley's sheriff of Silver Bow sums up the inherent corruption and oppression of the Company and voices his faith in the workers: "In defending themselves, these people will squeal on one another—and unless I don't know Montana this will smash that rotten ring of pirates and plunderers that have held this state in their grip for years."

GEORGE WESLEY DAVIS

Appearing around the same time as Braley's *The Sheriff of Silver Bow*, George Wesley Davis's *Sulphur Fumes; or, In the Garden of Hell* (1923) represents a considerable contrast in literary quality. Roeder accurately called it "the worst of the books about Butte appearing after World War I." Davis's book

The cover image of *Sulphur Fumes* (1923). George Wesley Davis's Butte novel is generally considered among the worst. *Collection of Aaron Parrett.*

is a nearly unreadable and highly contrived tale of the bastard son of a Copper King trying to claim his fortune after his father dies. The book is overtly anti-Semitic and presented in ponderously plodding prose. Its only redeeming feature is its perhaps unintended environmental message: the author misses no opportunity to complain about the omnipresent sulphur fumes. In fact, Davis never actually uses the name "Butte" and instead employs various dysphemisms: "the garden of Hell," a "region of Hades," "Dante's Inferno" and so on. In one particularly purple passage, he writes of "the dumping of molten slag from a trestle above precipitating tanks where hot sulphurated water from the mines steamed while it flowed, casting out a Satanic odor that suggested the atmosphere of hell."

An obligatory visit to the most destitute of the shacks in the Cabbage Patch leads to an encounter with twitching cocaine and morphine addicts, giving the narrator the opportunity to compare the commerce in illegal drugs in Butte to the Latin Quarter in Paris and its collection of absinthe fiends. The ecological devastation matches the political evils of the community; one of the ostensible heroes in the novel, Judge Howell, had "in his work uncovered many unusual dealings and, therefore, was not over-popular with the 'gang' or those out for 'graft' as so many were in those days." The book is a sensationalist indictment of Butte, with its dope fiends and hop heads, the sort of human precipitate that trickles down from the rapacious corruption of the copper barons. The scandals of Butte are set against a backdrop of the ubiquitous "sulphur fumes" of the title, matched by the scandal of Anthony Dunlap discovering his incestuous marriage to a woman who turns out to be his cousin.

The novel reflects in many ways the life of the author. George Wesley Davis (1861–1934) was involved in a rather celebrated probate case in the 1890s involving the estate of his uncle, Montana pioneer A.J. Davis (1819–1890), and several of the powerful mining interests in Montana. The case gained further prominence when the celebrated Robert B. Ingersoll agreed to represent the Davises and delivered a famous closing statement at trial that is a showcase of his talent for oratory. George Wesley Davis presents his account in a three-part book called *Truth and Perjury* (1918). The Davis case was followed in the 1890s with as much public interest as the O.J. Simpson trial a century later and, indeed, was dubbed by some as "the trial of the century."

The case was especially followed in Montana, as A.J. Davis was well known as among the wealthiest men in the state. Davis might have been the first merchant to bring goods up the Missouri River to Fort Benton and then across

the hills to Alder Gulch to supply the miners at the first major gold strike in the state. He was a shrewd and canny businessman, preferring to make his fortune providing goods and services to the hardworking miners rather than digging in the shafts himself. He was also among the first speculators to shift his focus to the promising veins revealed at Butte City in the late 1860s, where he eventually founded the first National Bank, established the famous Lexington mine and foresaw both the ascendancy of silver over gold and then copper over silver on the way to making what at the time of his death in 1890 was one of the greatest fortunes in the West.

Robert Ingersoll (1833–1899). Among the most famous orators of his day, he represented the estate of A.J. Davis against distant relatives who contested his will, an element of George Wesley Davis's *Sulphur Fumes. Courtesy of the U.S. Library of Congress.*

For a man who had his entire life been in and out of courtrooms, engaged in the unavoidable litigation that accompanies the creation of a financial empire, Andrew Jackson Davis surprised many interested people by dying without a will. Not only did he pass away intestate, but he had never married or "produced issue," as the Montana supreme court delicately noted. Furthermore, he had both a large personal fortune to be divided up among potential heirs and controlling interest in the most powerful bank in the newly created state of Montana. It could not have come as much of a surprise to his associates, then, when his distant relatives—eleven brothers and sisters from Iowa and parts east—emerged to claim their inheritance. One of them, a brother called John Davis, led the way.

As it happened, Andrew Jackson Davis's nephew, also named Andrew Jackson Davis, had for years been his partner in the bank and was both logically and legally the presumed heir to the business side of his uncle's

fortune. John Davis, however, sued for control of the entire fortune, prompting A.J. Davis the younger to resign his interest and control in the bank pending the years of litigation that would follow. The case commenced in 1890 and wound its way through the appeals process to the Montana supreme court in 1891, where it quickly became one of the most famous cases of the nineteenth century and without question the most celebrated and important case in the early years of Montana's statehood. *Sulphur Fumes* can't be called a roman á clef of the Davis case, but without question, George Wesley Davis used the novel as a platform for expressing his contempt for the judicial system in Montana.

George Wesley Davis also authored a memoir called *Sketches of Butte* in 1921, a book certainly more readable than *Sulphur Fumes*. It romanticizes Butte's earliest days and comments bitterly on the changes wrought by the copper development. "Butte in her days has had more interesting characters than any city of her size in the world, for they come to the camp from all points of the compass, and from all conditions and walks of life," Davis opines at one point and goes on to describe as an unremarkable moment in Butte history the day that Mary MacLane stood on Broadway "with a basket of cold boiled potatoes on one arm, and under the other a bottle of olives, while watching 'Callahan the Bum' try to commit suicide by hanging himself to an awning rope in front of a jewelry store." Davis insists it was an "actual occurrence," though it "attracted no particular attention in Butte."

Though Davis tends toward the off-color anecdote, it is clear he had an irrepressible love for Butte in spite of his sniping, and without question, *Sketches of Butte* is the best piece of prose he left behind.

George Wesley Davis, vice-president of Davis-Daly Copper Company. From *Resources and Men of Montana* (1913). *Courtesy of Montana Historical Society Research Center, Helena, Montana.*

REUBEN MAURY

The 1920s was one of the most fecund periods in American literature. Not only was it the decade in which the finest works of the "Big Three"—F. Scott Fitzgerald, William Faulkner and Ernest Hemingway—appeared, it was also a golden age of the short story and the "slick" magazines that fostered the careers of innumerable American writers. One of them, the *American Mercury*, was edited by H.L. Mencken, a titan of literary criticism and a first-rate intellect. In 1925, the *Mercury* printed an essay by Reuben Maury (1899–1981), under the pen name of Arthur O'Dane, called "Hymn to an Oasis," now recognized as one of the finest pieces of writing to emerge from Butte and a key entry in the canon of Montana literature.

Reuben Maury was the son of H. Lownes Maury, an attorney in Butte who had been a law partner and early champion of Burton K. Wheeler. Born in 1899, Reuben grew up in Butte. He published a book in 1928 called *The Wars of the Godly*, a history of the occult war between Catholics and Protestants in America. One section featured a brief account of the violent skirmishes in Butte in 1894 between Cornishmen (Protestants) and Irish Catholics over the anti-Catholic American Protective Association (APA).

Maury's ambivalence toward the vast legion of vacuous middle-class denizens of America sounds a note that Leslie Fiedler would strike twenty-

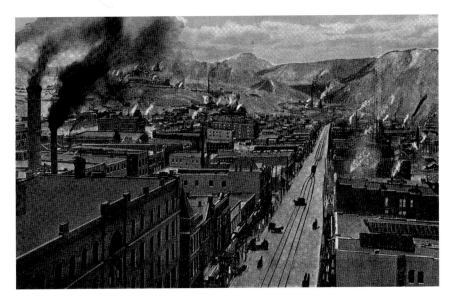

A postcard of Park Street in Butte, circa 1914. Artist unknown. *Collection of Aaron Parrett.*

five years later in a controversial essay called "Montana; or the End of Jean-Jacques Rousseau" (also known as "The Montana Face"). "A large part of my reasoning lifetime has been devoted to a fascinated speculation as to the reasons, if any there be, for the juice and savor that is Butte," Maury wrote, adding, "I love this common man of Butte and all his ways…and my chief joy in my hours of ease is to ponder on what it may be that makes him the sweet cynic he is." Fiedler would later be a little more highbrow and obscure in his turns of phrase, but a similar contempt for the Babbitts of America and particularly the West wouldn't be hard to see.

Interestingly, Maury's essay was inspired by Mencken, who, in a 1925 interview in the *New York World*, snidely quipped that he had never seen a decent piece of prose come out of Montana. Maury's "A Hymn to an Oasis" was a direct response to this barb, and Mencken promptly printed it in the *American Mercury*.

"A Hymn to an Oasis" bears critical scrutiny for other reasons. In the first place, it seems to sympathize with the Company, a stance that strikes one as incongruent to other aspects of the essay and to Maury himself, which may explain his use of a pseudonym. In 1938, Maury became an editorialist for *Collier's* magazine. His greatest coup came in 1941, when he won a Pulitzer Prize for distinguished editorial writing for the *New York Daily News*.

The period between *A Blind Lead* and Prohibition in Butte was a relatively prolific period and set thematic precedents for many of the novels that would appear later. In taking on the saga of the Copper Kings for the first time, Atherton and Braley set the stage for numerous reprisals of the theme that would follow in the ensuing decades. Similarly, Cohan's inauguration of the union versus the Company theme would be rehearsed again and again. In this period, Butte continued to develop its personality as a veritable literary character and a singular setting amid the vast landscape of the West.

AFTER THE WAR OF THE COPPER KINGS

The Literature of the Company Town

Butte Montana is a place where the Company is too big to beat. Where the house cut is always too steep and where victory, below ground or above it, consists in snatching a draw out of the jaws of certain defeat.
—Nelson Algren

Following the dash and fervor of the Copper King era, Butte descended into a grim cynicism under the yoke of Anaconda Copper Company control. The Company eventually controlled the entire state of Montana. The literature that followed in the wake of this historical shift reflected the mood of the town, and many of the novels in this period are practically concussive in their depiction of distressed miners, ruthless company thugs and appalling social conditions.

DASHIELL HAMMETT

Twenty-five years after Mary MacLane first put Butte on the literary map, Dashiell Hammett (1894–1961) published his classic hard-boiled detective novel *Red Harvest* in four installments in *Black Mask* in November and December 1927 and January and February 1928 (later printed as a complete novel in 1929), probably among the best-known and still widely read novels inspired by Butte.

The Big Ship (the Florence Hotel). *Courtesy of the Butte–Silver Bow Archives.*

As with Atherton and Braley's books, in *Red Harvest*, the city becomes a veritable character in the novel. In fact, the personification extends to rendering the name of the town as *Person*ville, corrupted, of course, to Poisonville. It must be pointed out that Hammett purposefully confuses the reader about the exact identity of the city, beginning with his famous opening sentence: "I first heard Personville called Poisonville by a red-haired mucker named Hickey Dewey in the Big Ship in Butte." The "Big Ship" refers to a well-known boardinghouse (the Florence Hotel) uptown in the mining district that was essentially a dormitory for miners.

In any case, after *Red Harvest*, "Poisonville" became synonymous with Butte. The real-life political corruption and violence fostered by the Anaconda Company as it consolidated total corporate control of Butte and the rest of the state helped solidify the association.

Dashiell Hammett, considered one of the finest mystery writers ever to take up the pen, was cited in his *New York Times* obituary as the "dean of the hard-boiled school." Born in Maryland, Hammett dropped out of school at an early age, eventually becoming a Pinkerton detective in 1915, an experience that was crucial to his narrative about Butte. He began publishing in the early '20s, basing his stories on actual events and people he had encountered. Although many who have written about Butte or used Butte as a setting for novels had socialist sympathies, Hammett was a card-carrying member of the Communist Party, largely because he was vehemently opposed to fascism. In the early '50s, his politics eventually landed him in a federal penitentiary after he was cited for contempt for refusing to testify against some communists accused of trying to overthrow the government. A few years later, he was called before the House Committee on Un-American Activities along with scores of other American writers, musicians and artists,

and he was blacklisted. He spent the last decade of his life ill and depressed, dying of lung cancer in 1961. Having served in both the First and Second World Wars, he was buried at Arlington National Cemetery.

The main character in *Red Harvest* is nameless, never identified as anything other than simply the "Continental Op," i.e., an operative in the Continental Detective Agency. More than any of his other works, *Red Harvest* depended on Hammett's intimate personal experiences, in this case as an operative for the Pinkerton Agency hired to help break the 1917 miners' strike that followed the Speculator disaster. That mining disaster—the worst in U.S. history—killed 168 miners, led to violent confrontations between miners and the Company and famously culminated in the lynching of IWW organizer Frank Little.

According to Robert Polito, "Hammett told [Lillian] Hellman

A photo of Dashiell Hammett posing as the Thin Man. Hammett's *Red Harvest* is probably the most widely read Butte novel even today. *Courtesy of the U.S. Library of Congress.*

that he had been offered $5,000 by the Anaconda Copper Mining Company to assassinate Little." Polito quotes Hellman, who later stated, "I think I can date Hammett's belief that he was living in a corrupt society from Little's murder." Like many Butte novels, but to a far greater degree than any other, *Red Harvest* exposes a town overrun by corruption reaching to the highest levels of business and government. The novel is strikingly grim and violent, with two dozen murders depicted. Nevertheless, the novel is no fantasy: virtually every book documenting this period in Butte's history reveals appalling disregard at every level for the rule of law or fair play.

Writing in 1925, Arthur Fisher attempted to find a suitable analogy for the real-life, ubiquitous tension in Butte:

> *What the Harvard-Yale game is to intercollegiate football, what the Davis Cup matches are to international tennis, what the Grand National is to the English racing world, the World Series to baseball, the Mardis Gras to New Orleans, or the Rose Festival to Portland, what a good county courthouse trial used to be before the days of the movie, all this and more the battles with the Company are to Montana. They form Montana's epic.*

Fisher's slate of candidates for the right metaphor at least conveys a sense of the preeminence of the struggle between labor and capital (or, more specifically, between the people and the Company), but it fails to capture the undeniably violent aspect of that struggle, a failure more than compensated for in Hammett's pitiless and unflinching novel. "Anybody that brings ethics to Poisonville is going to get them all rusty," comments the Continental Op mildly. Even Chief of Police Noonan—incorrigibly corrupt—defends himself thus: "If I hadn't been a pirate I'd still be working for the Anaconda for wages."

Hammett's novel had influence far beyond Butte: Nobel Prize winner Andre Gide summarized *Red Harvest* as "the last word in atrocity, cynicism, and horror." Critics of detective fiction consider *Red Harvest* as marking a critical shift in the basic conception of the detective. The righteous if unconventional Sherlock Holmes–type figure inhabiting a world marked by a clear moral order began to give way to the existential detective who is well aware that the taint of evil touches every corner of the universe, up to and including himself. As Raymond Chandler remarked in his *The Simple Art of Murder*, "Hammett pulled murder out of the drawing room and put it in the alley." In the case of *Red Harvest* and its Butte setting, murder wasn't relegated to the alley, either—it occasionally took place in broad daylight on the main streets and sidewalks.

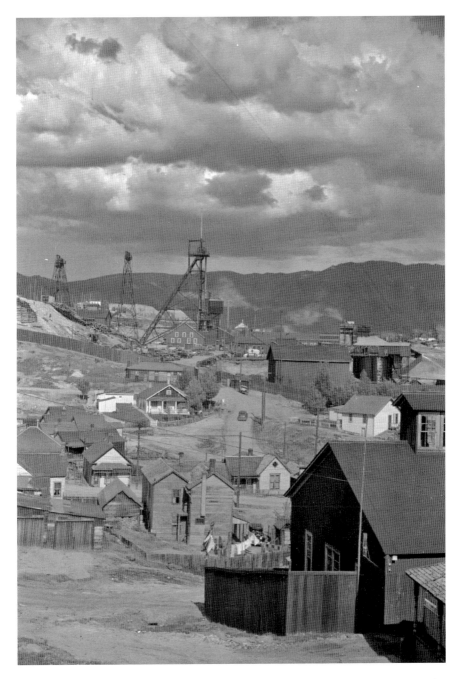

"Copper Miner Neighborhood," 1939. Photographer: Arthur Rothstein. *Courtesy of the U.S. Library of Congress.*

Like Hammett, the Continental Op feels overwhelmed by the mayhem, feeling himself becoming absorbed in its iniquity. At one point our narrator remarks, "Poisonville was beginning to boil out under the lid, and I felt like so much a native that even the memory of my very un-nice part in the boiling didn't keep me from getting twelve solid end-to-end hours of sleep." Anticipating later writers, Hammett envisions the pollution of Butte as more than just sulphur smoke and tailings dumps—that pollution becomes merely a visible manifestation of the deeper corruption of its city fathers and its police force and, somewhat superfluously, the depravity of the Company that controls everything. The poisons choking the city are not simply the arsenic-laden tailings piles leaching into Silver Bow Creek and the venomous smoke of its smelters. Accordingly, Hammett rechristens the city—named for its people—with a name that summarizes its moral character: *Poisonville*.

MYRON BRINIG

The same year that *Red Harvest* appeared in book form (1929) saw also the appearance of Butte's own Myron Brinig's debut novel, *Singermann*. Myron Brinig (1897–1991) deserves special attention in any survey of the novels of Butte for a number of reasons, not the least of which is that he was among the most prolific: of the twenty-nine novels he wrote, seven of them involve Butte. One of them, *Wide Open Town* (1931), is considered by many to be the quintessential piece of fiction associated with Butte, capturing the spirit and sense of the place at its peak with unparalleled fidelity. Not until Clyde Murphy's *The Glittering Hill* (1944) appeared over a dozen years later would a novel so poetically depict the city of Butte during its most famous historical period.

More than any of the other Butte novelists who spent a significant part of their lives in Butte except Mary MacLane, Brinig flirted with enduring literary greatness, having been celebrated as one of the country's most promising young writers in the 1930s, only to slide into utter obscurity in the autumn of his life. After 1958, he stopped publishing, and gradually, all his work fell out of print. Though his masterful prose has never received the renaissance it deserves, at least two of his finest Butte novels have been reprinted in recent years: *Singermann* (Arno Press, 1975) and *Wide Open Town* (Sweetgrass Books, 1993). In addition to those, five other novels at least in some way centrally connected to Butte have never been reprinted: *This Man*

Montana Street, uptown Butte, circa 1928. Photographer: Frank Ward. *Collection of Lyle Williams.*

Is My Brother (1932), *The Sun Sets in the West* (1935), *The Gambler Takes a Wife* (1943), *Footsteps on the Stairs* (1950) and *The Sisters* (1937).

No book-length biography of Bring has been published, although University of Montana professor emeritus Earl Ganz has done considerable research, culminating in both a biographical overview published in the *Speculator* and a historical novel, *The Taos Truth Game* (2006), based on Brinig's life and adventures in New Mexico with Mabel Dodge Luhan. Ron Fischer, professor at Idaho State, has also written a brief overview of Brinig's work that appears as the foreword to the Arno Press edition of *Singermann*.

Brinig was born in Minneapolis in 1897. Around 1900, the family relocated to Butte at the invitation of some relatives, a well-established Helena family called the Fligelmans. (This branch of the family happened to produce another writer, Frieda Fligelman, who achieved some notoriety in Helena.) According to Ganz, Brinig left Butte in 1914 to go to Columbia, eager to leave Montana, and came back to Butte in 1917 "only because he was drafted." Though he appreciated his early years in Butte as a great source of creative inspiration, Brinig never felt compelled to return and instead spent most of the rest of his life in New Mexico in the company of Mabel Dodge Luhan and the coterie of artists and intellectuals she gathered around her, much in the style of

Myron Brinig at a picnic. Photographer: Cady Wells. *Collection of Earl Ganz, courtesy of the Museum of Fine Arts, Santa Fe, New Mexico.*

Gertrude Stein. In the 1970s, Brinig moved back to New York City, where he spent his remaining years. He died in 1991.

Earl Ganz was largely responsible for resuscitating interest in Brinig and ensuring that he was represented in the canonical anthology of Montana literature, *The Last Best Place* (1989). Ganz was frankly mystified that Brinig had so completely vanished from Montana's literary memory. Brinig explained in conversations with Ganz that he had consciously given up his literary career because it seemed that public taste in fiction had changed, and his style—so well received and popular in the '20s and '30s—had simply fallen out of vogue. He gave up the writing game because he sensed that the work he had taken so seriously was

Myron Brinig on horseback. Photographer: Cady Wells. *Collection of Earl Ganz, courtesy of the Museum of Fine Arts, Santa Fe, New Mexico.*

"becoming more and more standard fare for middle-class readers to rent at local stationery stores."

When Ganz discovered Brinig's work and sought him out in the 1980s, Brinig had settled into relative anonymity in New York City but "seemed to have outlived his sense of failure and regained his youthful ego and voice, at least long enough to admit that his Butte novels were his best work and *Wide Open Town*, with all its flaws, his best book."

Though Brinig garnered enthusiastic and almost universally positive reviews for his first few books, later critics tended to dismiss much of his work on its literary merits. Tastes change, however, and while Brinig's Butte novels especially deserve a second look, a comprehensive study of Brinig is beyond the scope of the present work.*

Although both *Singermann* and *This Man Is My Brother* (also published in London as *The Sons of Singermann*) provide a fascinating and singular glimpse of the Jewish experience in Butte around the turn of the century, the obvious candidate for specific focus here must be *Wide Open Town*, since (as its title indicates) the book is *about* Butte. The lyrical style and subtle socialism in *Wide Open Town* anticipate Steinbeck's *The Grapes of Wrath* (1939), a feat especially impressive because *Wide Open Town* appeared in 1931, early in the Depression.

Like Hammett's *Red Harvest*, *Wide Open Town* is set against the backdrop of the boom years in the second decade of the twentieth century preceding America's entrance into the First World War. As America prepared for war, the tension between labor and capital in Butte grew especially heated. In June 1917, the Speculator mine disaster claimed the lives of 168 miners, prompting a bitter strike for better working conditions. Less than two months later, Frank Little was lynched for his role in organizing the striking miners, touching off a veritable war between labor organizers and the mine owners engaged in supplying copper for the war effort. The National Guard was called out in Butte to force the miners into the mines. The violence persisted after the war ended, and in 1920, Anaconda Company agents murdered Tom Manning and wounded more than a dozen others as they opened fire on striking miners. That incident is remembered as the Anaconda Road Massacre. As a result, the National Guard would occupy the Butte hill until 1925, on the pretext of preventing similar violence.

Since Brinig set his novel in the midst of this tense period in Butte's history, many of his contemporaries rightly understood *Wide Open Town* as

*. Brinig's first novel, *Singermann*, bears consideration simply for its unusual themes. The book also demonstrates that in its heyday, Butte was in many ways a miniature metropolis, a multicultural and cosmopolitan city comparable to America's largest cities, a point Mary MacLane had also made after she returned from New York City in 1910. In *Singermann* and its sequel, *Sons of Singermann* (1932), Brinig brings to life a Jewish family living in Butte in the first two decades of the twentieth century. *Singermann* is a remarkable novel for many reasons, not the least of which is that its author happened to be a homosexual Jew writing in a provincial part of the West. Leslie Fiedler lauded the book, writing that its only rival in adequately capturing the Jewish immigrant experience in America was Henry Roth's *Call It Sleep* (1934). And while many authors of Brinig's era were gay, few had the audacity to present gay characters in a novel with such open candor. In developing these themes against the backdrop of Butte, Brinig conveys the city as uncharacteristically urbane for the West.

an indictment of the capitalist system. By the time Brinig's novel appeared in 1931, it was clear that the economic crash of 1929 was far worse than what today's media would call an "economic downturn." On the contrary, it seemed clear to many that the entire capitalist system had imploded as a logical result of its inherent conceptual flaws. It was inevitable that the ideological clash between capitalists and laborers would become palpable in Butte; by the outbreak of the First World War, over fourteen thousand miners were working underground, and whatever improvements they had seen in regard to working conditions or their pay scale since copper had first been mined in the 1880s had been painfully earned in spite of bitter resistance from the mine owners. Whatever hardship and suffering the country was starting to feel in 1931 as a result of the Depression had been chronically intermittent in Butte, and the people of Butte were well exposed—yet hardly inoculated—to the violence that invariably arises when hungry and out-of-work citizens confront the powers of wealth controlling their livelihoods.

Wide Open Town charts the vicissitudes of the Irishman Roddy Cornett and his nephew John Donnelly. Cornett is a kind of town crier called a spieler, probably based on the real "street spieler," Harry Clifford, expertly memorialized in John Astle's essay in *Stories off the Hill*. In the novel, Roddy's nephew John has recently arrived from Ireland and is working as a miner. John falls in love with the prostitute Zola Petersen (auspiciously named after the French novelist Emile Zola [1840–1902]).

Butte in 1916 was a city vibrant with bawdy dance halls and taverns: "Primitive America is at play," observes one character. "This is the last frontier," comments another. And "America will never be like this again," the narrator reminds us. This seems to be a common thread in Butte narratives: the infamous wild and wooly West persisted in Butte long after it had vanished from other places, especially major urban centers, in the West, and Brinig gives it convincing life in *Wide Open Town*. As the protagonist John Donnelly remarks as he is on his way to visit Zola on East Galena Street (modeled on Butte's notorious red-light district, Mercury Street), "This was indeed a tempestuous town, a boiling town, a wicked town. The air captured you and filled you with notions, and anything, and awful thing might happen to you here, under these mountains."

But beneath the veneer of cheerful optimism seethes a sense of tension, an increasing animosity between the haves and the have-nots. From the balcony at a moving picture show at the Broadway Theatre, Donnelly "glowers" at the aristocrats in the lower section, the "suckin' rich…bleedin' the poor miner, keepin' him underground so they can wear furs an' silks."

Throughout the novel, Brinig pushes this anti-capitalist sentiment with a subtlety that rivals Steinbeck's handling of similar material in *The Grapes of Wrath*. In fact, many liberal critics were disappointed that Brinig did not push the issue more forcefully.

Instead, Brinig balances the anxiety and frustration of the obviously disenfranchised with the inexplicable hometown pride they often espouse. The 104-year-old character Old Martha, for example, refuses to leave Butte for Los Angeles at the urging of her children. "She had lived in Silver Bow for many years and the town was in her blood, the tumultuousness, the violence, the ecstatic color of the mountains and skies were fighting in her and would not let her go." Part of what gives Butte its cultural identity is the incongruity between the resentment of its inhabitants toward practically inhuman living conditions and their fierce resistance to the idea of leaving the place in order to improve their lot. Brinig clearly admired the tenacity of Butte's people in the face of adversity on so many fronts. At the same time, he respected their refusal to leave in spite of hard times, even if he himself sought escape at the earliest opportunity.

Oppressed people, especially those who feel rooted to a particular region, have a natural tendency to pin their hopes of salvation on the arrival of a hero from outside the community. In Brinig's narrative, that hero comes in the persona of labor organizer Phil Whipple, a character clearly meant to stand for Frank Little, who calls for a strike in response to the Company's move to lower the wage rate by fifty cents. Buoyed by exuberant renditions of the "Internationale," Whipple whips the miners into a frenzy with an impassioned speech, the pith and gist of which is that "it was high time the miners of Silver Bow cast off their chains and walked like free men and not like animals in captivity, shut up behind the bars of Capitalism."

In spite of the unresolved labor strife permeating the lives of its townspeople, Butte—as the central character in the novel—will clearly endure. By the end of the novel, in spite of the death of his uncle in a boardinghouse fire and the accidental suicide of his lover, John Donnelly wanders the town, realizing that Silver Bow is his home: "The familiar air filled him with gratitude and hope. Those who have lived in Silver Bow understand the teeming quality of the town, the way it has of reaching out to you, wherever you might be, and drawing you home." Unlike Mary MacLane, Brinig never returned to Butte, but he agreed with her that the place exerted an uncanny power of attraction for those who lived there, and like her, he understood that the place would always have an enduring life of its own.

Those who were critical of Brinig for failing to make his novel into an anti-capitalist screed were especially incensed that he failed to describe the grim and miserable conditions in the mines. Even though John Donnelly is a miner, practically none of the action takes place underground. Indeed, the novel opens with John Donnelly emerging after his shift from the Original Mine, and from there on, the narrative remains aboveground. For a novel with a clear sympathy to organized labor, this is unusual and quite a contrast to novels by later authors. Even Emerson's very early *Gray Rocks* (1894) contained underground scenes.

Myron Brinig with Mabel Dodge Luhan. Photographer: Cady Wells. *Collection of Earl Ganz, courtesy of the Museum of Fine Arts, Santa Fe, New Mexico.*

But this is precisely why *Wide Open Town* succeeds so well as a novel in general and as a Butte novel in particular: Brinig brings the stress and desperation of the miners toiling thousands of feet beneath the earth into the light of day and makes overt the connection between that suffocating and dangerous lifestyle below ground and the larger plight of industrial workers aboveground everywhere during the Depression. He distills from the exhausted misery of the miner the essence of Butte itself—its weariness, its resignation and the contradiction of its unwavering pride and unflagging hope.

James Francis Rabbitt

As it happens, another of the best novels about Butte also appeared during the Depression and was also penned by a fellow who spent a considerable part of his life in Butte. Though the title page lists R. Francis

The author's grandfather Alf Pettersen and fellow miners at the Anselmo Mine, circa 1945. Photographer unknown. *Courtesy of Bonnie Parrett.*

James (1903–1963) as the author of *High, Low, and Wide Open* (1935), the name was a pseudonym for James Francis Rabbitt, born in Butte in 1903. Rabbitt's father was an Irish immigrant who worked in the mines and died when Rabbitt was only three years old. His mother, widowed at a young age, raised three children on her own. She was also active in the effort to get women the vote in Montana, serving as the secretary of the Right to Vote Committee for several years.

The dust jacket of *High, Low, and Wide Open* indicates that Rabbitt was a jack-of-all-trades, having been "newsboy, miner, ranch-hand, locomotive fireman, office-clerk, and salesman in thirty-six states." Rabbitt evidently published nothing else in his life. According to a relative, he was a kind and intelligent man and a loving father who taught all his children to read at an early age. Rabbitt served as a cryptographer in World War II. He died in Houston, Texas, in 1963.

Although Richard Roeder observed that Rabbitt's book clearly owes a debt to the "books by Cohan, Davis, and Braley," he does not add that the title seems inspired by Brinig's book nor that the basic plot and characters are drawn from Hammett's *Red Harvest*. Nevertheless, Rabbitt composes a compelling, balanced narrative of his own, at the heart of which is a murder mystery. The fact that the murder itself occurs deep below the earth in a

mine shaft makes it somewhat original for a genre that has seen practically every imaginable mode of mayhem. The book reads much like Hammett or Chandler, featuring a miner turned hardboiled detective. The book ends with a great last line, echoing an epithet muttered by countless miners as they climbed out of the skip cage at the end of a shift: "She's deep enough." This line, like much of the dialogue in Rabbitt's book, captures an authentic sense of Butte and its idiosyncratic dialect, an aspect of verisimilitude lost on many writers who choose Butte as a setting. A blurb on the half-title tells us that "the author was born in a mining camp, and mucked ore 3,600 feet underground," a certainly plausible assertion given the fidelity to fine detail in the book.

Early in the book, Rabbitt directly connects the horrors of mining to the standard fare of the detective novel with one simple sentence uttered by the main character and narrator, Ray McFarlane: "There is nothing startling about seeing a dead man in the mines." An event that would elicit gasps from everyone in a drawing room is merely another mundane event below ground in the Butte mines.

Butte here is called Perch, probably a name inspired by Atherton's well-known book, although as noted earlier, references to Butte as "Perch of the Devil" appear much earlier. The Anaconda Company is loosely disguised here as the Golconda Copper Mining Company, a pseudonym with an interesting lineage:

A locomotive on Butte hill, circa 1930. Photographer unknown. *Courtesy of Lyle Williams.*

James Francis Rabbitt. Photographer unknown.
Courtesy of Gretchen Metz.

"Golconda" was the name of a diamond mining region in India that dates back at least to the tenth century. No doubt its phonological similarity to "Anaconda" made it a natural choice as well.

The protagonist McFarlane is only slightly less cynical than Hammett's Continental Op and more overtly sympathetic to the plight of the mine workers. Rabbitt conveys this sympathy with much more subtlety than Brinig and other writers who tend to put openly seditious speech in the mouths of their characters. McFarlane, by contrast, simply notes the irony in "bringing a stiff up from two thousand feet—just to put him back under six." In any event, the book abounds with what might have become classic hardboiled lines had the novel not vanished into obscurity. The chief of police, Larry McManus, for example, is described as "looking something like Abraham Lincoln might have looked, had the great President been Irish." In another telling metaphor, he describes the well-traveled pathway in one stope as being "packed harder than a banker's heart."

There is other evidence of Rabbitt's debt to *Red Harvest*: McFarlane claims to have been a private detective in the employ of the "Packingtons," doing the very things Hammett actually did for the Pinkertons, including strike-breaking. Having worked for the Packingtons for seven years, McFarlane has no illusions about the relationship between labor and capital, and he has no patience for those who would romanticize the drudgery of being a miner. "All hated the mines, although many had spent their working lives underground," he observes. "In fact, I never knew one miner who liked being a human mole." After a eulogistic reference to "IWW organizer

Small"—clearly a reference to the actual Frank Little—McFarlane shakes his head at "the richest hill in the world with its twenty gallows-frames, every one of them a marker, a tombstone for a thousand men who went down the hole alive—and were brought up dead."

Like many of the Butte novelists before him, Rabbitt captures both the abject ugliness of the hill and its curious sublimity: "By day, the richest hill on earth is also the ugliest, its slopes spotted by the leprous white of the dumped waste and tailings; its crest disfigured by grimy smoke-stacks and dirty fences and buildings. The darkness of night however, hid its disfigurements; and a multitude of lights gleaming and flashing against its black surface changed the great ridge into something beautiful."

But one of the most admirable features of this book echoes one of the striking themes in *A Blind Lead* and the works of Mary MacLane: a three-dimensional female protagonist who refuses to be constrained by the proprietary notions of the men around her. Therese DuBois, as the widow of the murdered Broderick, makes a definitive femme fatale, but she is even more memorable for being unapologetic about her intelligence and sexuality. In response, McFarlane breaks away from the mold of hardboiled gumshoe since he uncharacteristically admires rather than condemns her for these qualities: "You're not ashamed of being intelligent, are you?" he asks and then encourages her to pursue her theatrical aspirations on her own terms and to avoid (male) management. He also refuses to castigate her for her sexual appetite and, in fact, lauds her self-confidence when she delivers what must have been a shocking declaration in 1935. "I know what they say about me in town," she says, "but I don't care. They're content to stay with one man, to cook greasy meals over hot fires, to lose their looks and figures having a lot of kids. I don't want that; I won't have that. So they call me fast—because I will not be a fool—because I don't have to be a fool." Hammett's Continental Op, by contrast, avoids gender bias only because he exhibits misanthropy and misogyny in equal measure.

Rabbitt describes Mark Broderick, the murdered man's father, as president of a large bank and reputed to be the wealthiest man in town, a detail that must have been inspired by the actual A.J. Davis (1863–1941), longtime helmsman of the First National Bank in Butte.* The book presents this character as envied but respected by the locals for his wealth and particularly admired for remaining in the town rather than abandoning Montana for

*. This A.J. Davis was the nephew of the A.J. Davis discussed in Chapter 2 in the context of George Wesley Davis and *Sulphur Fumes*.

New York's high society, which was a habit of many of those who made vast fortunes from the Butte hill.

Little additional information is available about the enigmatic Mr. Rabbitt, aside from a letter from his publisher archived at Ohio State University regretfully informing Rabbitt that sales of *High, Low, and Wide Open* had "recently dropped to such an extent that we are having trouble disposing of the large stock we have" and offering him first option for buying remainders and "acquiring the plates and remaining publication rights."

The Depression-era novels of Butte follow the habit of their predecessors in at least two salient ways. In the first place, they tend to develop the conception of Butte as a type of character, a city with a personality that interacts intimately with and profoundly affects the lives of its inhabitants. At the same time, these novels tend to feature female characters who defy convention, asserting themselves as independent and intelligent in the company of men inclined to objectify them. The fact that Butte was built around a brutal and dangerous industry that often killed men in their prime and forced women into doing double-duty as both breadwinners and single parents no doubt contributed to a general atmosphere in Butte more conducive to inchoate feminism than might be found in more genteel parts of the country. On both counts, the Depression exacerbated tendencies that were already emerging in the earliest fiction produced in Butte.

Chapter 4

MODERN BUTTE

Writers of the '40s and '50s

Butte is baroque town.
—*Ed Lahey*

By the 1940s, Butte had gained enough distance from its glory days to develop a literary nostalgia for them. For the next few decades, Butte writers continued to revisit the past, but the intervening experience of company consolidation on the hill and the hegemony of the Anaconda Company perhaps encouraged sentimentalism for "the good old days," which, as the earliest Butte novels reveal, were anything but halcyon. By the 1950s, Butte and its lore had become a veritable staple of western America, of which pulp writers made quick triumph.

JOE DUFFY

Joe Duffy produced in 1941 one of the rarest and most sought-after novels of Butte, *Butte Was Like That*, written in reminiscence of the boom years. Duffy (1877–1955) was a consummate Butte man: he lived most of his life in Butte, though he was born in another bonanza mining town, Virginia City, Nevada, in 1877. Joe's father, Henry Duffy, had come over from County Mayo in Ireland to work in the coal mines of Pennsylvania but ended up out west in Nevada, first as a miner and then as a printer at the Virginia City paper

Amateur miners near the Four Mile in Butte, circa 1947. Photographer unknown. *Collection of Aaron Parrett.*

(the *Territorial Enterprise*), working alongside Samuel Clemens, who also did his time as a printer on that paper. Duffy's father moved the family to Butte in 1898.

Joe Duffy started out as a miner but eventually became a laundryman. In fact, Duffy often joked that he had a "L.D. Degree in steam laundry. The L.D. stands for laundry driver." He served Butte many years as an alderman on the First Ward, and he served a term as a Silver Bow County representative in the Montana legislature fifteenth session (1916–17). Duffy was well known as one of Butte's characters, a jokester who perpetrated for years the famous hoax of the "Centerville Ghost," an account of which appears in manuscript form at the Montana Historical society and which was one of the stories collected in the WPA anthology *Copper Camp* in 1943. Duffy was also known for impersonating other legendary Butte characters. According to grandson Michael Duffy, one of the best-known photographs of Fat Jack Kelly, the famous hack driver from the era of the Copper Kings, is actually not a photo of Fat Jack at all but, rather, a photo of Joe Duffy in blackface, dressed up as Kelly.

Duffy wrote a newspaper column that consisted mainly of his poetry in the *Montana American*, a Butte weekly, for years. Old Butte citizens also remember him as having produced numerous vaudeville shows and stage plays. Joe Duffy is buried at Holy Cross Cemetery in Butte.

Butte Was Like That lacks any kind of conventional plot but instead strings together one vignette after another that illustrates some detailed aspect of Butte life: in one chapter, Duffy evokes the oppressive heat of the deep stopes and the endless and filthy toil in the mines; in another chapter, he celebrates

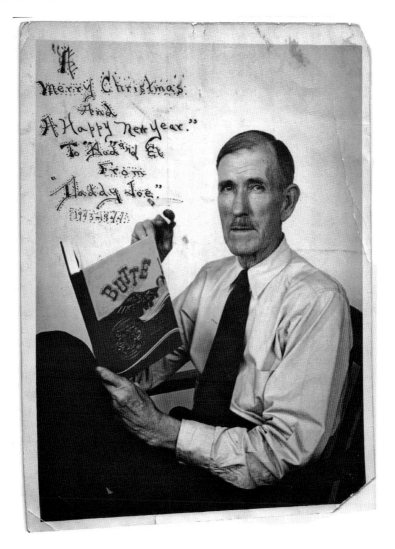

A Christmas photo of Joe Duffy holding his magnum opus, *Butte Was Like That* (1941). Duffy is revered as one of Butte's most memorable characters, and his book is highly prized by collectors. Photographer unknown. *Courtesy of Jane and Michael Duffy.*

"the Miner's Ball." Here is a chapter on the battle between the Butte Miner's Union and the Wobblies, and there a chapter on the jargon of the miners and the unique patois that developed on the streets and in the pubs of Butte. Duffy sets one scene in the infamous "Cabbage Patch"—bailiwick of hopheads, junkies and patent medicine addicts—and another in Dublin Gulch;

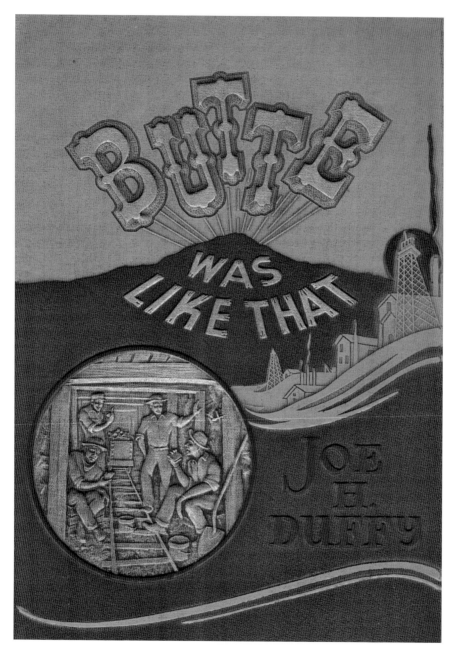

The embossed cover of *Butte Was Like That*. The cover was designed by Butte artist Charles W. Pearson. *Collection of Aaron Parrett.*

one in the "Big Ship" (a rooming house for miners that boasted over three hundred rooms) and others in nearly every nook or cranny Butte had to offer in its heyday. Duffy also paints a vivid portrait of the Columbia Gardens during "the biggest day of the year," namely Miner's Union Day.

James Joyce once bragged that if ever Dublin were to be destroyed by war or other catastrophe, the city could be rebuilt brick by brick from his descriptions in *Ulysses*; one could make the same claim about Butte, working from Duffy's *Butte Was Like That*. Duffy has a marvelous ability to resuscitate the Butte of his youth and turns a clever phrase or two in nearly every chapter. The impetus for his vignettes came from his work as a laundryman, an occupation that put him in contact with nearly everyone in town and furnished him with endless material. "A laundry driver gathers gossip with a ginger jar flavor," he explained. "What a newshound on the daily paper misses, the lad on the laundry wagon gets first hand." Occasionally, his extended metaphors prove difficult to track, though worth the effort, as for example when Duffy attempts to summarize the legal skirmish between Heinze and Amalgamated over stock dividends by reference to the similar business acumen of Henry Ford: "Henry Ford was experimenting at the time by connecting discarded tin cans with old bicycle wheels and making them run on suspicion. If and when, later on, the contraptions made their debut as 'Tin Lizzies,' the delayed dividends were needed for a down payment on autographed copies of the first editions of the run-abouts." Obscure as the passage may be, Duffy champions Heinze's efforts to enjoin the dividends accruing to Amalgamated and, in true solidarity with his working-class brethren, warns of the tendency for corporations to grow exponentially if unchecked.

CLYDE MURPHY

A few years later, one of the most widely read novels devoted to Butte, *The Glittering Hill* (1944), appeared. It won the first Lewis and Clark Northwest Award and indicated a promising career for its author, Clyde Francis Murphy (1899–1946), although he never published another novel. It is one of the tragedies of Montana letters that this novel has languished out of print for over half a century now, as Murphy's book captures the era of the Copper Kings with unusual finesse. His sense of plotting is impeccable, and a vein of ironic humor rescues this exercise in grim realism from wallowing in despair.

"Broadway looking East," 1939. Photographer: Arthur Rothstein. *Courtesy of the U.S. Library of Congress.*

Murphy was born in Great Falls in 1899 but moved to Anaconda in 1911. His father worked for the Great Northern Railroad, and he had been mayor of Great Falls for a period prior to moving to Anaconda. Murphy's father also served in the state legislature from 1912 until his death in 1935.

Clyde Murphy joined the navy in 1917 and received an honorable discharge in 1919, moving on to earn a law degree in 1923 from the University of Montana (then called Montana State University), after which he moved to Los Angeles, where he practiced law in Hollywood until 1939. After a successful career in law, Murphy decided to devote the rest of his life to writing. *The Glittering Hill*, appearing in 1944, was his only published book, but it caught the attention of two Hollywood producers, Sam Jaffe and Lloyd Bacon, who paid $75,000 for the film rights. They planned to cast Humphrey Bogart in the lead role as Nick Stryker, but Bogart chose another project, and the film was never made. Murphy died in 1946 while at work on a second novel, the typescript title of which was *You Can't Take It With You*. It was also a mining novel that would have been set this time in Helena, Montana.

The Glittering Hill is essentially a roman à clef, as Butte novels set during the era of the Copper Kings tend to be. In this case, the correspondences between characters and real people are rather simple to draw, in spite of Murphy's ironic disclaimer at the outset. That notice offers this proviso: "No actual person, living or dead, has been represented and such resemblances between characters and persons as appear were not meant to be ends, but means in an effort to create fictional characters who have the convincing truth." One wonders whether Murphy's inclusion of the disclaimer was an attempt to avoid the fate of William Mangam's splendid little exposé of the Clark family, *The Clarks: An American Phenomenon* (1941), an exceedingly rare book today because the Clark family had virtually all of the first print run destroyed.

The main story here concerns one Nick Stryker, who arrives in Butte from the East well educated and adventurous. He's both a ladies' man and an exceedingly canny businessman and politician and an opportunist in all three domains. As the novel unfolds, we realize that the central tension between Nick Stryker and Magnus Dunn for control of the most lucrative veins in the Butte hill is a thinly guised account of the battle between Marcus Daly (Magnus Dunn) and Augustus Heinze (Nick Stryker), while Walter M. Cole (William A. Clark) quietly builds an empire of his own.

Other clues to this roman à clef are myriad: Dunn owns a racehorse called Tipperary (Daly owned a famous horse called Tammany); Stryker has a degree from Heidelberg (Heinze was educated in part at Leipzig); Dunn runs the Python Corporation (Daly headed the Anaconda Company); and so on. The novel is rich with detailed descriptions of famous Butte neighborhoods and streets and features vivid cameos by some of Butte's most famous characters: Porky Sullivan, for example, is surely meant to represent Judge William Clancy,

THE CLARKS
AN
AMERICAN PHENOMENON
BY WILLIAM D. MANGAM

The dust wrapper of Mangam's *The Clarks: An American Phenomenon* (1941) featured the stern visage of Copper King William A. Clark. The book is scarce, presumably because the Clark family had nearly all the published copies destroyed. *Collection of Aaron Parrett.*

whom Augustus Heinze helped install on the bench and whom he relied on for favorable decisions.

If other writers decided to present Butte as a veritable character in its own right, Murphy goes further, depicting Butte as a sort of narcotic that changes the personalities of the characters who inhabit it; for example, the central character, Nick, for whom "[t]he town was like a drug to which he had once been addicted and then had renounced. A sediment of it still remained in his blood, deviling him to seek it again." To be sure, Murphy, like his predecessors, can't avoid personification: "To Nick, Butte was a real person. Butte, in a sense, was a hag, on whose brow every tree had rotted, twisted and died. Bald and rough and barren, her high laugh and wild crashing voice told the world she didn't give a damn." He goes on to call Butte a "a strumpet, black and angry and vulgar as she worked

The dashing and charismatic Augustus Heinze inspired many authors who took up the pen in pursuit of the definitive narrative of Butte. A consummate ladies' man, a daring speculator, a fearless litigator and an eloquent champion of the working man, Heinze made for a natural literary hero. *Courtesy of the U.S. Library of Congress.*

below her yellow eddying canopy of thick sulphurous smoke." His summary judgment of Butte echoes those that have appeared before, in Braley, in James and in Brinig: "For all of its noise, its smoke, its drunkenness and carousing, Butte was a great place. [Its] people had made Butte the friendliest, as well as the brightest and richest place on the earth."

Murphy, like some of his predecessors, portrays Heinze as a genius who prepossessed the miners in his favor by clamoring loudly for and delivering to his workers the eight-hour day and humane working conditions and a living wage, benefits that his competitors Clark and Daly had long lobbied against. Stryker also exploits the infamous "Apex law," as did Heinze to great advantage. A decade earlier, in his memoir *Pegasus Pulls a Hack*, Berton Braley

Augustus Heinze. *Courtesy of Bain News Service.*

summarized the qualities Heinze possessed that would make him such an attractive and natural character for a novelist to develop:

> *Take Heinze—a young mining engineer who came out of the East with nothing but uncanny geologic instinct, and a canny, daring and unscrupulous brain. A roisterer, a boozer, a gambler—who with no money, but with sheer intellect, effrontery, imagination, and courage, bucked all the Standard Oil millions behind the Amalgamated, and*

departed after ten or fifteen years with twenty-five millions, partly taken from Butte's Hill, but mostly taken from Amalgamated stockholders. A person and a personality so amazing that the cold facts about him can't be written as fiction—too incredible.

Many writers after Murphy would rehearse the story of the conniving Heinze and how he hoodwinked the corporations even though he was vastly outgunned. The story lends itself naturally to one of the most appealing and mythic narratives—David against Goliath—in which the underdog triumphs and becomes a hero and champion to the common folk. Of course, more careful scrutiny of the historical record reveals in Heinze a man more unsavory than savior and as much a heel as a hero. Nevertheless, Braley correctly understood Heinze's appeal and appreciated that Heinze's antics delayed for ten or fifteen years Amalgamated's total consolidation of all the corporations on the hill, which led ultimately to the Anaconda Company monopoly that held the state in an economic and political vise for nearly half a century.

BUTTE IN THE "PULPS"

Paul W. Fairman's *The Heiress of Copper Butte: A Great Ranch Romance* (1951) in many ways condenses the historical narrative of Butte into a few intense, laconic sentences composing its prologue. In spite of its subtitle, the book has nothing to do with ranches but is, like its obvious predecessors, a fast-paced adventure novel that uses the legendary stuff of the "richest hill on earth" as a vehicle. In spite of a misleading but classic "pulp" image of a gunfighter in a flat-topped hat with his arms around a doe-eyed damsel in a low-cut dress, the novel is actually quite good.

According to a brief biography on a science fiction website, Paul Fairman (1916–1977) spent a good part of his career as an editor at two of the most famous magazines in that genre: *Amazing Stories* from 1955 to 1958 and as founder and editor of *If* from 1952 to 1958. Between churning out a spate of science fiction novels and stories, Fairman found time to write a formulaic western featuring Butte during the years of transition from the wild and lawless West to the wide-open company town. It appeared under two titles, *Copper Town* and *The Heiress of Copper Butte*, both bearing copyright dates of 1952. Toward the end of his career, he also wrote television scripts, most notably two episodes of the popular *Partridge Family* in 1971–72.

A scan of *Copper Town* by Paul Fairman. *Collection of Aaron Parrett.*

In *Copper Town*, Fairman summarizes in brisk but poetic prose how after the Civil War, miners "found her, a great ungainly saddleback of a hill in a bleak and lonely Montana valley," only to watch the placer gold soon fail. "Left in peace, she bandaged her sides with new-grown grass," he writes, only to have her scars reworked for silver. But then the "colossus" arrived in the form of Abraham Gault, who discovered copper and founded Copper Butte, "filled with tough and brutal men." In a laconic and graphic gloss on Social Darwinism, Fairman explains that the miners had to be tough and brutal: "With muscles of less than iron, they would be lost in the competition. If their lungs were less than leather sacks, they spat them out on the floors of the tunnels and died."

As in the case of Murphy and many later writers, Fairman lays the foundation of his novel on the actual exploits of Augustus Heinze. To its credit, *Copper Town* tells the story with economy and verve, which are no doubt the expected virtues of a book that might very well have been categorized as pornography in 1951. And yet, after a racy scene in which the female lead, Kit Douglas, enjoys an uncharacteristically vivid sex scene with Drake Hughes (who is meant to depict Augustus Heinze), she descends, much like Molly Bloom in her post-coital daze in *Ulysses*, into a stream-of-consciousness reverie—not the usual stuff of a soft-core '50s western pulp novel. In any case, this novel must be among the first—if not the only—to present the two leading characters effecting sexual congress at the two-thousand-foot level of a mine deep beneath the "richest hill on earth."

Though hardly as racy as *Copper Town*, Dan Cushman's *The Old Copper Collar* is also a fast-paced potboiler of a book. Like *The Glittering Hill*, the novel is a roman á clef set a few years later and focusing on William A. Clark rather than Heinze, in particular Clark's political feud with Daly that culminated in a controversial campaign and a rigged election. Accordingly, *The Old Copper Collar* could easily be classified as a "Helena novel," since most of the skirmishes in the clash Cushman depicts take place in the capital city.

Born in 1909, Dan Cushman was among the most successful Montana writers of the '50s and was at the center of a literary circle that included such Montana writers as Norman Fox, A.B. Guthrie Jr., Robert McCaig and others. He claimed to have written over two million words for the pulps—western stories, for the most part, in magazines such as *Six Gun Western*, *Ace-High* and *Northwest Romances*. His most successful novel, *Stay Away, Joe* (1953), about Indian life on a Montana reservation, was made

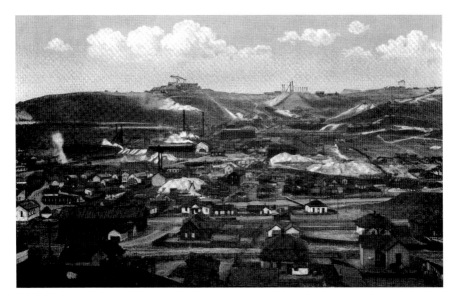

A postcard of Meaderville, 1910. Artist unknown. *Collection of Aaron Parrett.*

into a film starring Elvis Presley (1968), now considered a cult classic.[*] Cushman died in 2001.

The Old Copper Collar is a rollicking, humorous tale told from the point of view of the son of a copper baron trying to buy his way into the U.S. Senate. Mr. H.B. Bennett (a thin disguise of W.A. Clark) has sent his son Fred to Helena with a valise containing a quarter million dollars to buy votes in the state legislature. (Prior to the ratification of the Seventeenth Amendment in 1913, U.S. senators were elected by their state legislatures rather than by the populace.) Fred is a fiddler and librettist for musical revues in New York, more interested in drink and women than politics, but he fulfills his father's request. In the course of the grand jury investigation that follows, he demonstrates that the charges of corruption and vote-buying leveled by the opposition essentially amount to sour grapes at not having offered large enough bribes themselves.

Clearly Cushman aims to parody the famous scandal of 1899–1900 when the U.S. Senate at first recognized Clark's election but then refused to seat

[*]. Although James Welch made news when he publicly vetoed any inclusion of *Stay Away, Joe* in the "Bible" of Montana literature in 1989 (*The Last Best Place*, ed. Kittredge and Smith), the novel earlier had been given the imprimatur of Vine Deloria Jr., who, in *Custer Died for Your Sins* (1969), called it "the favorite of the Indian people," adding that "anyone who can read, appreciate, and understand the spiritual forces brought out in [this] book will have a good understanding of what Indians are all about."

Clark in the aftermath of an investigation that ended on April 13, 1900, involving over ninety witnesses who revealed that Clark had bribed his way into the appointment. According to the U.S. Senate files, "In a high-pressure, well-organized scheme coordinated by Clark's son, Clark's agents had paid mortgages, purchased ranches, paid debts, financed banks, and blatantly presented envelopes of cash to legislators."

In her review of Cushman's book, famous western writer Dorothy M. Johnson remarked that *"The Old Copper Collar* tells a funny story, the background of which happens to be bribery on a scale so vast that you just can't help admiring it," a testament to how blatantly corrupt the Copper Kings were. In fact, Johnson noted, "As fiction, it is somewhat easier to believe than the facts about the fight W.A. Clark put up in 1899." This would not be the first time someone observed that the extent of actual scandal in Butte far exceeded anything a novelist might dream up.

Another western writer, Giles Alfred Lutz (1910–1982), also devoted a novel to Butte that is surprisingly among the best. Lutz was a prolific pulp fiction author, writing westerns, sports stories and erotica under a half dozen different pseudonyms. In 1962, he won the Western Writers of America's Golden Spur award for his novel *The Honyocker,* an accolade that demonstrates he was more than simply a hack. Lutz seems to fall into that category of pulp writer who lacked literary pretensions and didn't resent being categorized. Like other accomplished writers saddled with the label, such as Jim Thompson or Stephen King, Lutz followed his own muse and ignored the critics, knowing full well that highbrow fiction is just another genre, most of it produced by technicians rather than artists, and *de gustibus non est disputandum.*

His *Halfway to Hell* (1963), like Fairman's *Heiress of Copper Butte,* has all the earmarks of a pulp

Dust jacket photo of Dan Cushman. *Collection of Bill Borneman.*

novel, right down to the fustian blurb on the back of the paperback: "Butte, Montana: it was built overnight out of blood and sweat and dreams—a yowling, brawling, boozing hellhole where a man could wake up poor and die rich between sunrise and sunset." The branding of Butte on the front cover is even more exorbitant: "A lusting, brawling, blood-swilling boomtown that ate men raw and spat out their ruined dreams."

Nevertheless, in spite of the sensationalism of the blurbs and the stereotypical gunfight depicted on the front cover, *Halfway to Hell* transcends the genre of pulp western. Lutz certainly makes use of stock western conventions—a bad man who is irredeemably evil, a complex "good guy" who shares features with the bad man and similar counterparts in the women competing for his affections. But the prose sings, and where most westerns devolve into the hackneyed clash between rancher and homesteader, *Halfway to Hell* is about mining entirely, with a majority of the action actually taking place below ground—a point of verisimilitude avoided by many more "literary" Butte novels. And because so much of *Halfway to Hell* actually takes place in the mines, the narrative exudes a sense of urgency, the action ratcheted in intensity by the claustrophobic atmosphere in which it unfolds.

Like many other Butte novels, *Halfway to Hell* has elements of a roman à clef, but in this case, the author freely alters history for dramatic effect. For example, here Marcus Daly becomes a full-blown character under his own name in this novel, as does William A. Clark, while F. Augustus Heinze is demonized under a different name—Brock Carlton—and appears as a psychopathic murderer and rapist. Most novels of Butte that involve the war of the Copper Kings can't help but make Heinze the hero—the dynamic and dashing young genius who outwitted and usurped the thrones of both Daly and Clark, who in comparison were drab, predictable and stolid characters, even in real life. Lutz defies convention by making Heinze a villain far more maleficent than the historical record actual shows.

Lutz personifies Butte as much as any of the other authors discussed in this essay, only in this case, Butte assumes a juridical, almost Old Testament sort of personality—characters frequently consider how their actions will be "judged by Butte." This nuance should fascinate the postmodern literary critic, since Lutz pushes the pathetic fallacy to the point that Butte takes on the persona of a monolithic God who weighs his citizens in a harsh balance, with the characters being forced to live out their lives in an existential drama of biblical proportions. In fact, the novel ends with the heroine renouncing the deity that is Butte: "Butte can say anything it wants about me," she proclaims just before she meets the hero in a carnal embrace.

"Entering Butte," 1939. Photographer: Arthur Rothstein. *Courtesy of the U.S. Library of Congress.*

Lutz clearly borrows from previous writers (he even names a main character "Murphy," possibly in deference to Clyde Murphy, since in some respects the plot resembles his *The Glittering Hill*). As well, Lutz's descriptions of Butte just before the turn of the century display as much literary craftsmanship as any other Butte novelist and perhaps drive home more than most the human responsibility for its ugliness. "The dirty brown cloud hanging over Butte was none of God's making," he writes, reminding readers the pollution was man-made and that "it was strong enough to kill every blade of grass and the flowers and trees within a radius of miles." Lutz connects the ugliness above ground to the unsavory motives of human greed, writing, "Butte sat on wealth as great as the world knew, and men lived like animals to get at it."

Below ground, even the industrial beauty of the hill covered with headframes against the backdrop of twilight disappears, and miners enter a confining "world of no light." More than one Butte writer could not resist the impulse to see in the spectacle of mining and smelting an allegory of Christian theology: the mines as a descent into Dante's Inferno, the oppressive smoke and sulphur providing decoration for a town clinging to the mountain in a "Perch of the Devil."

Lutz also presents the reality of mining violence in graphic detail: at one point, miners race to the hardware store for "a brace and bit" to drill

through a man's skull to relieve pressure on his brain after having had his skull crushed by a shovel. Fans of Cormac McCarthy will doubtless appreciate Lutz's vivid descriptions.

Lutz, like some of the novelists considered in the next few chapters, collapses several decades of Butte history into a few years in order to exacerbate the sense of urgency and tension. He conflates, for example, the labor unrest in the late teens and early twenties with the underground warfare in 1903–4 waged by minions of Daly and Heinze over disputed ores and also with Clark's ignominious bribery of the state legislature to win a seat in the national Senate in 1899. Pulp fiction or not, *Halfway to Hell* succeeds where more ambitious and credentialed writers dealing with the same material do not.

Robert McCaig's *Haywire Town* (1954), set in Butte in the early 1950s, is another crackerjack tale, this time involving a town caught in the stranglehold of a sinister police chief who happens to be in cahoots with ruthless businessmen.

Born in Seattle in 1907, Robert McCaig grew up in Great Falls, Montana, from the age of eight. His father had been a miner and suffered from silicosis, better known among miners as consumption, often abbreviated to the even

Dust jacket photo of Robert McCaig, 1957. Photographer: Carlton L. Lingwall. *Collection of Aaron Parrett.*

more ominous sounding "the Con." McCaig's father died shortly after they located permanently in Great Falls, where Robert graduated from high school in 1923 at fifteen years of age. At eighteen, he began working for the Montana Power Company (which until the 1980s was an Anaconda Company subsidiary), for which he worked until his retirement in 1972. He died ten years later, having published a dozen books, including one of nonfiction.

Haywire Town demands attention simply because it must be among the first Butte novels to deviate from having mining as the central focus. This novel is only peripherally concerned

with mining and instead uses an industry ancillary to mining—the electric power industry—as the backdrop for the action. This shift in perspective makes sense, given McCaig's own background, but it also corresponds to the last stage of the mining industry in Butte and the concomitant shift from deep-shaft mining to the open-pit mine than began to literally swallow the old Butte hill into the maw of the Berkeley Pit. The main character is an electrical engineer who revitalizes the ailing power grid and its generators in order to liberate Butte (here called Tempest) from the clutches of its nefarious town fathers bent on control of the mines and extorting the townsfolk with exorbitant power rates.

The protagonist, Ben Colby, observes at the outset of the novel that Tempest looked "more dead than living," its buildings marked with "chinks of crumbling masonry" and "long-broken windows." He goes to work for the Caliban Power Company, a family-owned operation on its last legs and operating at a loss. Tempest is compared to Butte, but it seems clear that the town as described is Butte itself. By the end of the novel, Colby has rescued the power company from the clutches of his enemies, thwarted the criminals out to kill him and exposed the corrupt city officials ruining the town. He's won the girl as well and realized that Tempest is "a swell little town" with "the finest people in the West."

NORMAN MACLEOD

Although most of the book is set in Missoula rather than Butte, the poet Norman Macleod's novel *The Bitter Roots* (1941) deserves mention in any survey of Butte fiction. Set during the years of U.S. involvement in the First World War, the book documents the labor struggles that plagued both Butte and Missoula, which were complicated by the intervention of federal troops and the laws against sedition that were enacted in response. Because the federal troops were dispatched to force miners on strike into the mines in putative support of the war effort, many feared that the United States was verging on totalitarianism. In Butte, the crisis was especially poignant.

Norman Macleod (1906–1985) was a notorious drunk, often alienating fellow writers and friends, and equally famous for his aimless drifting from one town to another. But along the way, he founded or helped operate dozens of small journals and magazines, leading one critic to note that "Macleod is

Dust jacket photo of Norman Macleod, 1941. Photographer unknown. *Collection of Bill Borneman.*

among the most frequently cited in Hoffman, Allen and Ulrich's authoritative *The Little Magazine: A History and Bibliography.*"

Born in Salem, Oregon, in 1906 and raised in aristocratic surroundings for the first few years of his life in England, Macleod spent his adolescence in Missoula in the years 1917–22, which formed the basis of his novel *The Bitter Roots.* In various memoirs and interviews, Norman Macleod later reminisced about those years, revealing that among his friends was one Pauly Maclean—the bold and reckless brother of Norman Maclean and the focus of Maclean's most famous book, *A River Runs Through It* (1976).

Pauly also figures as a character in *The Bitter Roots.* The events in Butte that were sparked when the Miners Hall was blown up by saboteurs in 1914 led to the lynching of Frank Little a few years later and the famous confrontation between miners and the National Guard, all of which spilled over to Missoula, a timber-milling town that supplied lumber for the mines in Butte. Macleod particularly admired William Dunne, editor of the socialist paper the *Butte Bulletin,* a vocal enemy of the Anaconda Company, and cited him as an inspiration for his own labor-oriented work.

In a nutshell, socialists and many unionists in general viewed the First World War as nothing more than the powers of monopoly forcing working-class men from one country into vicious battle with working-class men from another. They understood the profits and wealth enjoyed by the wealthy to have been purchased at the price of millions of working-class lives in the war. Bill Dunne was among the most eloquent and vocal critics of the war in Europe, and Macleod features him in *The Bitter Roots,* where Dunne argues that "the real war was going on in Butte. The stuff in Argonne had been a sideshow."

Douglas Wixson neatly summarizes the history of unionism in Butte prior to the events of 1917 when he writes, "Butte was called 'the Gibraltar of unionism,' but in fact the Butte Miners' Union never called a strike from its founding in 1893 until its demise in 1914. More radical was the Western Federation of Miners

The 1914 destruction of Butte Miner's Hall. Photographer unknown. *Courtesy of Lyle Williams.*

that organized Butte miners, and still more radical was a splinter group, the Industrial Workers of the World, that had separated from the WFM."

These were the years in which the Anaconda Company amassed its greatest power, subjecting all of Montana, but especially Butte, to its overwhelming influence. Nearly every historian of Montana from Joseph Kinsey Howard on has deplored this period as among Montana's most shameful. In fact, John H. Toole, brother to K. Ross Toole, in his history of Missoula, *Red Ribbons* (1989), wrote, "Never in the history of America has a business corporation so completely controlled a sovereign state."

Frank Little, 1914. This photo is stamped "I.W.W. Missoula Montana." *Courtesy of International Workers of the World and Wayne State University.*

The period beginning just before America's entrance into the Second World War and leading into the 1960s, as reflected in the literary output of Butte, is perforce a chronicle of the often acrimonious tension between labor and capital and the effect of that drama on the lives of men and women in Butte. The long period of Anaconda Company hegemony reinforced an ambivalence already evident in the *geist* of Butte from the days of the Gilded Age: on the one hand, a sense of futility and resignation bordering on anomie, tempered on the other hand by a tenacious resolve to outlast the external forces hedging them in.

Chapter 5

THE PSYCHOLOGY OF
DECAY AND ENDURANCE

*In some ways Butte appeared to me to be the industrial apotheosis of that
proverbial city built upon a hill.*
—Ivan Doig

The 1960s marked a significant shift in the literature of Butte, a reflection to some extent of the dramatic shift from deep shaft mining to the development of the Berkeley Pit. Whereas the postwar economic boom had contributed to some momentous changes in American culture, it seemed that in many ways progress had bypassed Butte. The years of the Copper Kings had created no shortage of misery and stress for the working classes, but writers of that era also conveyed a sense of hopeful possibility in their books: Butte was still a place where anything was possible. In the years following the war, writers began to reflect on the enduring conflict between labor and capital, a clash that had grown hopelessly one-sided after the Anaconda Company achieved monopolization of the hill. Consequently, the novels considered in this chapter tend to be less sanguine than their predecessors and almost as cynical about Butte as the Depression-era writers like Hammett had been. At the same time, some of the most inspired and expressive prose ever produced about Butte can be seen in these works.

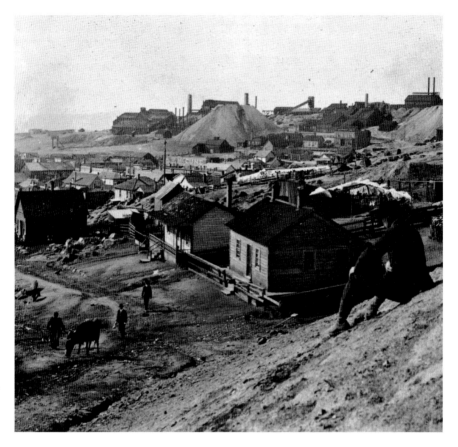

Walkerville, a neighborhood in Butte, 1905. Photographer: William Rau. *Courtesy of the U.S. Library of Congress.*

DAVID MACCUISH

One of the finest Butte novels to appear in the '60s was David MacCuish's *Do Not Go Gentle* (1960). A novel of the Second World War, *Do Not Go Gentle* follows the coming of age of one Norman McLeod in Butte in the years leading up to the war and his experiences on Guadalcanal. The majority of the novel takes place in the Pacific, but the first third of the book provides a vivid portrait of Butte. One of the first points of interest in the book is the name of the central protagonist: Norman McLeod, a name that comes very close to Norman Macleod, author of the novel *The Bitter Roots*, which also takes place partly in Butte (see previous chapter). The real Norman Macleod taught poetry at various high schools and colleges all over the country,

including Butte and Missoula, and it is possible that MacCuish had Macleod in mind when he named his main character.

MacCuish was born in Butte in 1924, and he draws from his own experience of growing up in the mining city in composing the novel. After the war, MacCuish went on to become a professor of literature at Riverside in California in the 1960s, having written his 1950 master's thesis at Claremont College on the Irish playwright George Faquahar (1677–1707). Aside from an occasional column in the Riverside literary magazine, MacCuish appears to have published little else, though he did publish a lecture presented in 1965 at Riverside called "The Tyranny of Reason," in which he urged students "to attach more importance to their inward perceptions and less to what they mistakenly believe are the hard facts of existence."

David MacCuish. Photographer unknown. *Courtesy of Riverside College, California.*

MacCuish described his novel in 1960 as "a boy growing up through three rapid and essentially tragic phases of his life." He explains that his purpose was to show "that our strengths—or the very things we believe are our strengths—are very often our weaknesses, and our weaknesses, that we so often try to conceal and to distort under falsity are very often our strengths." MacCuish acknowledged that his novel was bleakly existential but that it did offer a point of redemption: McLeod does manifest in the end "a desire to endure in a world that seems to be purposeless and driven by insanity." This helps explain the early setting in Butte, since McLeod clearly associates the relentless toil of mining and its debilitating effect on the community as a kind of pointless, purposeless madness. Although the book received flattering reviews, including four columns by Wirt Williams in the *New York Times*, *Do Not Go Gentle* appears to have been MacCuish's sole published novel.

Like many Butte works, *Do Not Go Gentle* depicts Butte as a living, breathing being with an identity all its own, but MacCuish does so with fervent skill:

The city of Butte spread out below him in splotched patterns of blacks and reds, all twisted and lumped into a spider web of tangled trestles, scaffolds, buttresses and crazy stairs twisting up to squat houses, their paint forever scaling as though all the buildings were infected with a loathsome disease. Everywhere were the mine hoists and acres of black cinders and the gray slag heaps invading the town, seeming to possess it with a hideous intent. Circling them and devoid of any growing thing were the mine dumps, changing now into huge lumps of sick yellow as the sun moved toward evening.

MacCuish also personifies the city as a casualty of war, prefiguring the horrors he will see on Guadalcanal, when he envisions "the paralyzed indolence of the street, like a crutch thrown out from the sprawled fingers of a blind and disfigured body, its flesh torn, lying motionless below him." The young Norman overhears a snippet of song coming from a neighbor's house and the phrase "Avalon" and wonders whether the city would have assumed a different character under a prettier name: "What if they had called it Avalon instead of Butte? Would not the mere sound of that word made a difference? Something green and white. Something lovely. Even a word a

MacCuish was a well-loved professor at Riverside College. *Do Not Go Gentle* (1960), his only novel, was a bestseller. Photographer unknown. *Courtesy of Riverside College, California.*

little bit redeeming?" Nearly every author who writes of Butte confronts its ugliness, but few comment on the name of the town itself as a symptom of its disease. *Nomen est omen*, said the old Romans, and every Montanan knows that the name "Butte" is the butt of many Montana jokes.

The young Norman in *Do Not Go Gentle* leads a life of suffering on every front: an overbearing and cruel father who humiliates him for his interest in books, who is himself a victim of silicosis contracted in the mines; a self-absorbed and indifferent mother; and a community of other children surrounding him who are ignorant, vicious and quarrelsome. David MacCuish's father, like McLeod's father in the novel, died from silicosis in 1938 after having been a lifelong miner in Butte. His obituary in the *Montana Standard* (April 17, 1938) confirms as well that he died at the Veteran's Hospital, Fort Harrison, outside Helena, sixty-five miles south of Butte, suffering the same fate as McLeod's father in *Do Not Go Gentle*.

At one point, McLeod climbs the hill to the rough shack his family calls home in Walkerville (a neighborhood just north of and a few hundred feet higher on the hill above Butte) and turns to survey the town. Once again, MacCuish characterizes the town as an ominous entity with the monstrous power to reduce its inhabitants to brutes:

> *The city of Butte lay beyond it, russet and black in the graying sun. The powerful and the ignorant specter, haunting their lives with its crushing and unthinking malevolence. Turning them into clawing animals, smashing and biting in their savage darks. Scorning the beautiful and lusting after the obvious and cheap; purveying their flesh and their souls into idiotic masturbation by which the very spirit died in revulsion and slow exhaustion.*

MacCuish effectively foreshadows the horrors that await his protagonist in the Pacific Theater by presenting Butte as a monster analogous to war itself—a creation of human beings that somehow takes on an identity and power of its own and whose primary purpose seems aimed at the destruction of desperate men and women. What may strike twenty-first-century readers as an overly harsh assessment would not probably have fazed anyone who actually lived in Butte during the Depression.

MacCuish's analysis in the preceding passage captures the essence of Butte in another subtle way as well. He provides a kind of explanation for the aesthetic sensibility of the Butte public, a kind of etiology of its crass taste. Even today, Butte exhibits traces of a lingering aesthetic bordering on kitsch—manifest in everything from houses painted in gaudy colors to

Our Lady of the Rockies to Evel Knievel Days. MacCuish distills the essence of Butte down to desperation and resignation, two features of a general mood that leads to a cultural atmosphere of "the obvious and cheap." Mary MacLane had performed a similar critique a half century earlier, cataloguing her contempt for Butte taste in both the *Story of Mary MacLane* (1902) and *I, Mary MacLane* (1917).

When Norman's father dies, his mother and sister flee Butte for the East, but at loose ends, he remains, partly out of a determination to prove his father wrong about whether he could endure working in the mines. He becomes a "nipper," a runner deep beneath the earth who transports heavy drill bits to the miners drilling into the rock faces. The work is exhausting, but Norman achieves intimate familiarity with the realities of working underground: "The coughing and the spitting in the dust. Disjointed phrases in the torn earth. The snapping of lunch pails. The ripple of words saying things about sex, love and life; far removed from any light. The mixed dialects, mingling and conversing. The laughter without any dialect at all. The heavy laughter always the same. The spitting and the coughing without any dialect either. The brotherhood of the deep earth had buried them all together."

His ally in the mines is Tango, a self-proclaimed "Rasputin of the richest hill on earth," who is a similarly intelligent young man with a taste for books, jazz and intellectual conversation. The two of them work their shifts in the mine but spend their off hours discussing literature, parsing the music of Debussy and philosophizing. But in cases where Norman seethes with contempt for Butte and its people, Tango accepts the town and its citizenry for what they are. Norman disdains them for their ignorance of Melville and Faulkner and their insensitivity to music or art, but Tango refuses his arrogance. "If they want that stuff, it's there for 'em, Norm. Just like you and me. The point is, it's too late for most of 'em, see? Hit them with the idea of what life could really be, what it could have been for 'em beyond Butte, Montana—I mean, really corner them and make the picture stick, an' you'll break their hearts. It's too late for 'em, pal."

After Tango dies in a gruesome accident in the mine, Norman spurns Butte and his impulsive foray into mining. "It was the work and the mines and the stupid belief of the men that they were important as they groveled in the earth" that cements Norman's urge to leave Butte and join the marines after Pearl Harbor. "How can we do it?" he asks himself. "Year after year, same thing. Bodies hardening and the minds being timbered in and forgotten in the lives that become a tunnel, and the vein of ore dwindles away; and then the darkness comes in again, and the water pours forever." Norman

succumbs to the pathetic fallacy, embodying Butte with a mind and soul and maleficent ulterior motives, ultimately going down in the mines to see for himself the heart of evil laid bare. Expecting the worst, he isn't disappointed, but once he finds himself in the fresh hell of Guadalcanal, it dawns on him that the evil and complacency he abhors go far beyond a dirty old town.

In a last conversation he has at the mine before leaving town, the old-timer Gallagher, a veteran of thirty years below ground, sees through the fallacy that leads Norman to blame the city of Butte for his gloom: "It's sometimes we're thinkin' it's a hard life or a dirty town we're runnin' from, but it ain't them things a'tall." Nevertheless, Norman's last glimpse of Butte as he departs the town forever leads to a final meditation: "'The richest hill on earth,' he said, and looked at the mound of snow by his feet. Having raped the valley, the giant lies in corruption in the shadow of the beautiful mountains. He stared again at the town. And the maggots bore and suck forever in the incandescent glow of its darkness."

RICHARD K. O'MALLEY

A decade after MacCuish's fine novel, Richard K. O'Malley published *Mile High Mile Deep* (1970), another compelling Butte novel that avoids the Copper King era, instead setting the action in the 1920s. Born in 1911 in Portland, Oregon, O'Malley's family moved to Butte when he was a small child. He worked for the Associated Press most of his life, writing *Mile High Mile Deep* while on assignment in Europe as bureau chief in the 1960s. The novel is very nearly a memoir, based as it is on actual events from O'Malley's life growing up in Butte. When he republished the book in a handsome new edition from Clark City Press in 2004, publisher Russell Chatham wrote in his introduction that "O'Malley's voice is never angry, bitter, judgmental, cynical, or in any way crying out for more justice than was possible. Thus, the verbal picture of Butte, Montana in the 1920s is as clear as any photograph." O'Malley died in 1999, but his second novel, *Hobo: A Depression Odyssey*, was published posthumously in 2002.

More than one critic has praised *Mile High Mile Deep* as the best of the many books about Butte. Many things come together well in this novel: a simple, engaging style; an intimate familiarity with Butte in the 1920s; sympathetic characters; and a narrative with a smooth sweep that encompasses almost every aspect of Butte's history without feeling contrived. The memoir-like

Richard K. O' Malley, author of *Mile High Mile Deep*, considered by many critics to be the novel that most completely captures the essence of Butte as "the Mining City." Photographer unknown. *Courtesy of Burke (O'Malley) Kintli.*

narration recalls Jean Shepherd's *In God We Trust, All Others Pay Cash* (1966), with the grit and urgency of something like James T. Farrell's *Young Lonigan* (1932). The story starts with our narrator about ten years old and tracks him to sixteen, when he and his best friend go to work in the mines. The novel effectively shows how the momentous decision to become a miner, like many life decisions, often comes about casually, leading to consequences a person can't possibly anticipate. Our narrator, an intelligent and clear-headed young man, decides to work a few years in the mine and save money to pay for college. His mother makes his lunch on the first day of his new job, hands him the lunch pail and

O'Malley was an Associated Press bureau chief in the 1960s in Europe, where he began writing *Mile High Mile Deep*. Unidentified photographer. *Dust wrapper photo from the Mountain Press edition, 1971.*

says, "Well, you and your father can be happy now. You've got your emblem of ignorance like the rest of them." Her son responds with ominous irony, "Ma, it isn't like I was going down in the hole for the rest of my life."

O'Malley punctuates the main narrative with brief meditations on the Butte landscape, a technique in some ways similar to Steinbeck's interludes in *The Grapes of Wrath*, which allows the omniscient narrator to offer some of the most insightful passages about the industrial landscape of Butte. One of the most moving examples comes in a section simply titled "Winter": "On the Hill, the cables snaked over the gallows frames down the hole and the rock came out and the miners worried away in the gloom, prying out the ore, blasting it, shoveling it, carting it away. The pumps throbbed like great metal hearts and the air was warm and dank and dusty. And up above, the winter walked across the valley."

O'Malley delivers an enviable performance in *Mile High Mile Deep* that lends credibility to the critic who remarked, "If you only read one book about Butte, make sure it's this one." Unless it's a version of the Copper King saga you're after, O'Malley's book does seem to fit that bill. O'Malley also made this story of a common man in an industrial town a chronicle of the working class in general, helping cement the concept of "Butte, America." As a blurb in the Mountain Press catalogue for 1971 noted about the book, "It's Butte—and maybe every town where ethnic groups gather under the shadow of a dominating industry."

CAMDEN WELLS

One of the more obscure novels about Butte is Camden Wells's *The Improper Bostonian* (1971). It is worth a glance simply because of its unusual plot: a lower-class young Bostonian woman named Lillany McLane ends up traveling to Butte in 1880 with her charming new husband, who turns out to be an incorrigible drunkard and gambler. After killing a man, he gets sent to prison, and after suffering a series of even worse misfortunes, Lillany happens to meet a wealthy Boston man who has come to Butte to invest in the copper mines. Lillany marries for a second time, returning to Boston, only to discover that her first husband has bequeathed her half of his profit from a mining property he had acquired before going to jail. Her unanticipated wealth provides her with a sense of independence, obviating the shame she feels for her humble origins and poor life choices.

The narrative succeeds in the vein of *Sister Carrie* (1900) or *The Rise of Silas Lapham* (1885)—nineteenth-century tales of the Gilded Age that expose the depravity begot by greed and the pervasive desperation of the underprivileged. Lillany, like Sister Carrie, is hardly a faultless heroine but distinguishes herself as woman who can hold her own in the "man's world" of the nineteenth century. Although more than half of the action of the novel takes place in Butte, it seems clear the author had never set foot in Silver Bow County. Aside from a few perfunctory references to copper and mining, there's little here capturing the spirit of Butte itself.

DONALD MCCAIG

Donald McCaig's *The Butte Polka* (1980) stakes out an interesting claim among the novels of the Butte hill: it takes place in 1946 and involves the famous strike that year against the Anaconda Company, though it conflates several other, earlier formative events in Butte history, anachronistically incorporating them into the action—most notably the Speculator disaster of 1917.

McCaig was born in Butte in 1940. He graduated from Montana State University in Missoula (now University of Montana) in 1963 with a degree in philosophy. He was the nephew of Robert McCaig, author of *Haywire Town*, discussed in a previous chapter.

The Butte Polka, though it gained a few favorable reviews, was less positively received by critics in Montana. Historian and MSU professor Richard Roeder panned it as one of the worst books ever written about Butte. Roeder seems to have resented McCaig's free play with historical events, apparently missing the larger purpose of trying to convey a realistic sense of what Butte *felt* like. One wonders how closely Roeder read the text, since a comment like "there are pointless digressions and occasional time sequences that become a disorganized mess" is simply false, whereas "the book fails to convey any convincing sense of the lives of Butte wage earners" and "there is not a memorable [character] in the book" tell us more about Roeder's tastes than McCaig's talents.

In point of fact, the book succeeds as one of the best Butte novels: it is lyrical, enigmatic and authentic. The peculiar dialect of longtime Butte natives is rendered here as accurately as in any book since Duffy, and the jargon of the miners and their families comes across with as much verisimilitude as R.

Donald McCaig's dust jacket photo for *The Butte Polka*. Photographer Andreas Antypas. *Used by permission of Donald McCaig.*

Francis James's *High, Low, and Wide Open.* On top of that, the novel is expertly constructed, with a coherent and compelling narrative arc, vibrant characters and sentence after sentence of well-wrought prose.

The novel opens with a strike imminent. The narrator and protagonist, James Mullholland, summarizes the situation: "During the War, wages were frozen. The Company's profits multiplied a couple hundred percent—all those copper shell-casings and tank radiators and hydraulic lines and posthumous medals—and the Company'd passed on zero to the miners." The narrative collapses a half century of labor struggles in Butte with convincing deft, contextualizing the 1946 strike into a long history of unionization and corporate greed, complicated by "red scares." With far more credibility than most novels that treat the theme, McCaig's book presents a cast of multifaceted characters struggling for fairness and justice against the behemoth of a malevolent Company in collusion with a corrupt government.

In one revealing scene, Mullholland, in search of his brother-in-law, Joel Kangas, a suspected Red who has mysteriously vanished, confronts the crooked district attorney. Mullholland pretends not to know Kangas and pretends to commiserate with the DA's anti-communist diatribes. At one point, the attorney claims that Butte "has always been a Red town. Biggest Red town west of Moscow." The attorney explains that "the Reds want a strike. This Kangas is yellin' his head off. Strike! Strike! Strike! Now, honestly, do you think this town needs another copper strike?" Mullholland responds with the suggestion that maybe Kangas should get what Frank Little got, to which the attorney casts a cool eye. When Mullholland mutters, "3-7-77," the attorney acknowledges the cryptic reference and says, "We don't need no vigilantes anymore. All we need is good Americans. We let the good Americans know who these Reds are and they'll take it from there.

All we gotta do is let Americans know who their enemies are." Thus, in one subtle and brief scene, McCaig draws an uninterrupted line connecting the ignominious history of vigilantism in Montana's early history to the reactionary suppression of labor just after the war, exposing the machinery of collusion between big business and conservative politics.

Given these literary merits, it seems Roeder's visceral contempt for the book stemmed from the wholesale liberties McCaig took with actual historical events in order to achieve the climax of the book, conflating, for example, the famous 1946 strike with the famous Speculator disaster of 1917. But in doing so, McCaig collapses a long chain of events in Butte involving the clashes between the working class and the tyrannical Company, all of which played an integral part in creating Butte's singular identity. McCaig's book succinctly evokes the *geist* of Butte in passages of a few pages here and there, a feat that no academic historian of Butte has been wholly able to accomplish. In any case, McCaig makes clear at the outset that his novel "is a work of fiction, not history" in a brief disclaimer on the flyleaf.

McCaig joins the company of many other Butte novelists in making his female characters strong and independent. Mullholland feints at a romance with Gail Stinson, the lead reporter on the city news desk at a Company-owned paper. Before sleeping with him, she makes clear that "I want a career, Jimmy. I don't want to end up a poor man's helpmate." Later in the novel, Mullholland presses her about marriage. "I told you already," she says. "I grew up with three brothers and a father. I'm tired of picking up after men."

McCaig's Butte novel stands out for yet another reason: though it departs from a strict fidelity to diachronic history, it nevertheless apprehends the failure of the labor movement in Butte, ending as it does with a grim and resonant note of defeat. Arnon Gutfeld succinctly explains why labor was so powerful during the War of the Copper Kings and why their power so quickly dissipated afterward:

> The era of the War of the Copper Kings (1889–1903) was known as the "golden era" of labor at Butte. Because the War of the Copper Kings had been fought in the political arena, labor's votes and support had become objects to be courted and bought. After 1903, the situation changed radically as labor engaged in internecine warfare and was faced with powerful mine owners.

McCaig uses the novel to dramatize in a readable way the fact of that failure and what it has meant for subsequent American history, expressed in

the much more abstruse but penetrating analysis of Jerry W. Calvert in *The Gibraltar: Socialism and Labor in Butte, Montana, 1895–1920*, in a discussion of the failure of the Socialist Party to "gain a permanent foothold" in Butte:

> *The weakness of the American trade union movement and the absence of a socialist party help explain the weakness of America's social welfare commitments and how the distribution of income and wealth has remained substantially inegalitarian and virtually unchanged through a succession of Democratic and Republican administrations.*

Butte, Montana, is, in addition to whatever else it has come to represent, an enduring monument to the exploitation of the working class at the hands of unregulated corporate industry and the protracted and often painful demise of the American labor movement, a phenomenon just as difficult to encapsulate in academic *wortsalat* as it is to convey in a literary novel. The ugliness of the Butte hill cannot be measured by the omnipresent tailings piles or the number of its ramshackle and abandoned buildings; part of its ugliness is psychological. If it is visible at all, it can only be seen in the lines of the old-timers' faces—those vanishing few who remember what it was like to labor beneath the earth for a pitiful wage, in constant fear of poverty or death. Part of Butte's enduring ugliness is an inherited feeling of anxiousness that continued to linger long after the mining went away, an anxiousness that was born of feeling hemmed in by gargantuan forces—the constricting power of the Company, the conspiracy of corrupt government at every level, the constant threat of one's livelihood being snatched away if the mines shut down or if a strike was called or, worst of all, an accident struck, leaving widows and orphans. That ugliness persists in Butte as a sort of resignation to fate and decay, a mood of impending doom reinforced by a collective memory of a past that includes tragedies like the Speculator disaster, the lynching of Frank Little and the sacrifice of the Columbia Gardens and neighborhoods like Meaderville to the voracious lust of the Company.

The mood of resignation evoked by these novels matches that of the era in which they were written, an era that culminated in the Company's ultimate monument to its flagrant contempt for the hill and the people who had made its unparalleled wealth possible: the Berkeley Pit.

Chapter 6

LIFE IN THE INDUSTRIAL SUBLIME

Butte Literature Since 1990

For mixture, for miscellany—variedness, Bohemianism—where is Butte's rival?
—Mary MacLane

By the 1990s, the word was out, at least among the überhip: Butte, America, was among the last authentic "American" places left in the country, if by "authentic" one meant a country built on the ashes of an always vanishing frontier. Clearly something about Butte continues to hold the American imagination, as if by geographical electrolysis, everything *cool* about the old Route 66 had been precipitated out and re-crystallized for eternity near the continental divide way up in Montana. Meanwhile, the mining was over, except for the modest digging going on at the east pit. The main pit was filling with a toxic lake that made headlines for killing several hundred snow geese that had made the mistake of deciding to rest there on their way south.

It helped that in the early 1990s, writers and critics began referring to Montana as "the Last Best Place," even giving that name to the state's gargantuan literary anthology. Needless to say, while Butte writers formed a whole section of that anthology, the advertising slogan did not seem to apply to Butte itself, which instead seemed to serve as a reminder of everything that had gone wrong with the rest of the country, an economic and industrial pathology that acutely afflicted Butte.

This new wave of hip Butte acolytes were well aware of the irony that at the very heart of the state that called itself "the Last Best Place" was a

Federal troops in Butte, 1914. Unknown photographer. *Courtesy of Lyle Williams.*

city that exemplified some of the worst environmental destruction ever perpetrated on the planet. In fact, that irony alone seemed to fuel literary and artistic interest in the place. Even if the landscape evoked dread, there was something redemptive in the honest tenacity of the people who inhabited it, something inspiring in their existential equanimity.

Consequently, dozens of novels and films have appeared in the last twenty-five years that use Butte as a setting. The next two chapters consider a representative sampling, as an exhaustive treatment of everything that's been produced on Butte since 1990 would no doubt entail a book of its own.

ED LAHEY

Of the novels about Butte published in the twenty-first century, the late poet Ed Lahey's *The Thin Air Gang* (2008) vastly outshines its rivals. The novel (which he described to publisher Russell Chatham as a memoir) evokes comparisons to the greatest of the noir novelists of the '50s and '60s: it has the flavor of a Jim Thompson novel, though Lahey—one of Montana's finest and most respected poets—adds a dimension of philosophical introspection in his prose that exceeds the expectations one usually brings to a crime novel. It contains echoes of David Goodis's classic, *The Burglar* (1957), as the book is told from the point of view of the criminal, though part of the theme in Lahey's book is that "crime" is a relative term, especially in Butte.

Lahey (1936–2012) was born in Butte and achieved notoriety as one of Montana's preeminent poets. Like his father before him, he spent a good part of his life eking out a living in the mines, a hardscrabble existence that he punctuated with several years at the university in Missoula and an apprenticeship with Richard Hugo. His poems, many of which are about Butte and mining, were collected in *Birds of a Feather* in 2005. His close friend and fellow poet Mark Gibbons has immortalized Lahey as "the old miner king of poetry."

Like his predecessors Dashiell Hammett and James Francis Rabbitt (see Chapter 3), Lahey tells his story in a way that illustrates how often crimes such as petty theft and bootlegging are the last resort of desperate men and women in tough times, while at the same time making a subtle case that the more insidious and victimizing crimes are always perpetrated by corrupt but powerful men operating in capacities sanctioned by society. At one point in the story, as the protagonist Jake Lowry and his accomplice "The Colonel" begin to run off a batch of corn whiskey, Lowry reflects on his partner: "The Colonel was one of those men unable to make it legally, soured by a mean society that honored the strong as cheap labor, and that worked men to death in the copper mines and mills for the sake of the treasure the owner hoarded."

Making illegal booze becomes a natural response to the folly of Prohibition, as well as a rational and more lucrative alternative to slaving in the mines. The threat of doing hard time should they get caught by the federal agents seems less terrifying than being buried alive or choking slowly to death from silicosis. Lowry comments that it was no wonder "socialism was as popular among the miners as were shamrocks and corn squeezin', and somehow they went together and cancelled one another out except as expressions of hope for a way out of the present." The miners worked themselves to early graves "trying to scrape up enough to eat and, if they were feeling lucky, to buy a bottle or visit the girlies." And no matter how kindly they would be treated in the night, they had to "make it back to the portal of the shaft at dawn when the whistles blew, where they got on board the cages that took them down a hundred feet a second into the hot, wet darkness of the earth."

In Lahey's book, as in many hardboiled novels, the so-called criminals often exhibit a keener moral sense than the businesspeople they compete with or the lawmen who pursue them. His novel in this sense recalls one of Jim Thompson's best and most well-known novels, *The Killer Inside Me* (1952), about a psychotic and murderous sheriff, fittingly made into a film shot in Butte in 1976. Lahey presents Lowry and his gang as victimized members of a working class wrung out by the Depression whose only chance is to make and sell illicit whiskey—a situation they recognize as colossal in its irony. As Lowry and the Colonel shop around Butte for the equipment they'll need for running their still, the Colonel remarks, "Ain't this a funny damn country. They make booze illegal, and whole industries grow up to aid and abet the moonshiners," to which Lowry tersely replies, "That's capitalism."

Lowry sees the law enforcement agents out to thwart him and the Anaconda Copper Mining Company bosses as elements of a seamless continuum: being blackballed and having your "rustling card" cancelled by a shift boss or mine superintendent for "agitating" would destroy a man's livelihood just as surely as a fed chopping up a still with an axe. And in both cases, the law and the men who enforced it were corrupt, since both corporations and moonshiners used bribes to "do business." After Lowry is arrested for being "drunk and disorderly" by a crooked cop and a disgruntled tavern owner working together, his only way out of jail is to pay off the jailers and the judge with jugs of his whiskey.

Lowry, like Norman McLeod in David MacCuish's novel, possesses an intelligence and sensitivity that make him frustrated with the apathetic resignation of the working-class men and women around him. The miners complain bitterly about working conditions and their miserable wages, but they

lack the fortitude to organize and stick out a long strike, and in the same way, the men he encounters in the local jail exhibit "a kind of broken-hearted acceptance of fate, a willingness to throw in the towel rather than organize to fight." He recalls how Clarence Darrow himself had learned in Chicago that most cons were "perfectly willing to take the blame" and that "they preferred not to recognize the deeper evil in the social spider web that snared them in inescapable poverty and drove them to crime."

Lahey weaves his tale with finesse, convincing the reader with slight and subtle sentences that moonshining in Butte during the Depression was just one rendition of a desperate drama in which everyone in the country not born into wealth and privilege was forced to play a part. Anxiously eluding the police

The Butte poet Ed Lahey, 2001. Photographer: Roger Dunsmore. *Courtesy of Roger Dunsmore.*

becomes a powerful metaphor for scraping by on a subsistence wage in constant fear of injury or getting fired. Lahey deftly evokes the sense of stress that poverty creates, and he shows how those at the bottom are enmeshed in a system of relentless, overlapping injustices. In doing so, he collapses nearly a century of life in Butte into a few months in the 1930s, capturing the mood and tenor of Butte in ways that few twenty-first-century novelists are able.

The Thin Air Gang, unlike its counterparts, however, comprehends the disquietude of Butte during the Depression without simply blaming the city as some volitional force beyond the control of the people who inhabit it. Lahey makes clear that the forces of fate are often a scapegoat we use to avoid holding actual individuals or companies responsible for the profound imbalance in wealth and opportunity in a place like Butte or, for that matter, in the country at large.

IVAN DOIG

Ivan Doig's *Work Song* (2010) is set in Butte in 1919, two years after the hanging of Frank Little and a year before the Anaconda Road massacre. The novel is a whimsical treatment of the tension between unions and the Company—perhaps, as some critics have noted, a trifle too blithe and breezy. The protagonist here, Morrie Morgan, first appeared in Doig's novel *The Whistling Season* (2007), set in eastern Montana. And even though Doig is a writer's writer, crafting sentence after sentence of well-wrought prose, it's hard to ignore the sheer fun of the book.

One of the main characters here is Samuel S. Sandison, a thin disguise of Granville Stuart, the Montana pioneer who played a role in nearly every scene in Montana history until he died in 1918. Doig depicts Stuart in the last decade of his life as the head librarian at the Butte Public library, a worldly-wise philosopher and curmudgeon dismayed at how easily the whole state has become accustomed to wearing the "Copper Collar." Doig manages to work baseball, boxing and a boardinghouse romance into the mix, altogether softening the edges of Butte's brittleness.

Doig often presents what will by now be easily recognized themes in the literature of Butte with unusual economy, generating what are very nearly aphorisms. For example, he captures the conception of Butte as a microcosm of America and adds an even finer gloss when he quotes the words of Mary Hagan as the slogan of the waves of immigrants from all over Europe to the mines: "Don't even stop in America, just go to Butte."* Or consider his encapsulation of the phenomenon of mass immigration itself: "It was as if Europe had been lifted by, say, the boot heel of Italy and shaken, every toiler from the hard-rock depths tumbling out here." The line "If America was a melting pot, Butte was its boiling point" recalls Dashiell Hammett's *Red Harvest*.

By the time we get to Doig, certain elements of the historical Butte novel have become formulaic, and certain scenes and characters are practically obligatory: the wake scene in which hangers-on get hopelessly drunk, the widowed miner's wife scrambling to make ends meet, the rabble-rousing Wobblie and so on. The challenge, of course, is to adhere to the factual kernels around which the legends have grown without letting them become too calcified as clichés.

Although some may charge Doig with not taking the Butte story seriously, a more reasonable perspective would simply be that he's

*. The full quote, etched in stone on the wall of the Butte–Silver Bow Archives, is "Don't forget, Lizzie, when you get to the New World, don't stop in America. You go straight to Butte."

emphasizing the good humor associated with Butte and reminding the world that no matter how grim conditions got in Butte, and no matter how ardent or irrational their pride, people in Butte never forgot how to laugh, even at themselves on occasion. In this, Joe Duffy's *Butte Was Like That* seems to have been an inspiration.

Doig continued the saga in a sequel to *Work Song* called *Sweet Thunder* (2013), which observes the further adventures of Morrie Morgan in Butte, this time in the year 1920, now married to his former landlady, Grace Faraday.

RICHARD WHEELER

Any place that has a history filled with such captivating events as the War of the Copper Kings tends to attract those fiction writers bent on revisiting the past and revitalizing the cultural memory of those years with "historical" novels. And indeed, as we have seen, the majority of Butte novels are set during the Gilded Age, when Clark and Daly feuded on the hill before Daly died, just as the twentieth century was beginning, and when Heinze arrived to do battle with the Standard Oil interest that acquired Daly's properties.

Richard Wheeler, author of over two dozen novels and winner of six Spur Awards, took on the Copper King saga and managed, as Ezra Pound enjoined, to make it new. It helps that Wheeler wields a pen with a terse finesse rivaling John Updike but also that he very subtly makes what is by now a threadbare Montana story relevant to the current clash between progressives and a corporate political culture in the United States. He starts by making one of the main characters a newspaperman—a nineteenth-century media lapdog selling his services to the highest bidder in a town where the newspapers are owned by mine owners with agendas. One can't read *The Richest Hill on Earth* (2011) and not think about Rupert Murdoch or Clear Channel. As more than one historian has pointed out, the battle between Clark and Daly was waged primarily in the media and the voting booths. Consequently, the partisan schism in Butte in 1892 was in some ways a harbinger of our present-day political polarization. It probably is also no coincidence that Wheeler published *The Richest Hill on Earth* just a year after the Supreme Court's infamous decision in *Citizens United*, which unraveled campaign finance laws, including Montana's Corrupt Practices Act (1912), which had been passed in direct consequence of William A. Clark's shameless bribery in his bid for a Senate seat.

Red Alice is the heroine of this book, a fiercely independent feminist who refuses to knuckle under to a crooked union boss who pressures her to marry a member of the rank and file looking for a wife. Instead, she becomes an agitator, bent on exposing the horrors of capitalism while striking a blow for women's rights.

The Richest Hill on Earth offers an interesting blend of history and fiction. The background material Wheeler narrates about the Copper Kings and their jockeying for control of the hill conveys the details given in classics such as Michael Malone's *The Battle for Butte* (1981), but at the same time, he brings the Butte of that era alive through the consummate power of his storytelling. Wheeler's novel, not surprisingly, is the only Butte novel that contains a long list of reference works in its acknowledgements page.

DOROTHY BRYANT

What is perhaps the most convincing evidence of the enduring and uncanny power of Butte is that novelists continue to use Butte—that is, the Butte of today—as a setting for novels.

The title of Dorothy Bryant's book *The Berkeley Pit* (2007) is a double-entendre: it refers both to the open-pit mine in Butte and the city in California that is home to the university. The narrative conflates the story of Harry Lynch, a refugee from Butte, Montana, just out of the navy who is trying to get an education, and the story of Berkeley in the '60s. The story is a divided labor that never fully succeeds, though the passages concerning Butte offer an interesting perspective on Butte in the 1970s and early 1980s.

After serving a hitch in the navy, which he joined to escape Butte and the inevitability of working in the mines like his father, Harry Lynch at age twenty finds himself in Berkeley in 1969. Cynical, jaded and at loose ends, he winds up in a creative writing course taught by a thirty-something community college professor who finds herself mesmerized by his tales of squalor and desperation in Butte and the horrors of industrial-scale mining. Lynch is contemptuous of the Berkeley Pit, especially resentful because opening the pit destroyed his native Italian neighborhood known as Meaderville.

Certain passages of Bryant's overly ambitious novel at least partly capture the history of Butte in the years from 1955 (when work on the pit commenced) to 1988, when the novel ends as the last efforts at mining vanish and the city of Butte sinks into economic despair. Much of the angst

of Butte in those years is evoked via artifice, as for example when Harry takes LSD in Berkeley and has horrible nightmarish visions of the mine shafts: "My father must have taken me once when I was a baby. I was in the cage, alone, and the cable started screaming, and the cage dropped, down and down and down…people…were screaming, and then there were no cages, no shafts, it was all open, and people raining down into the pit and screaming and clawing at the walls, at each other, and me."

After Lynch returns to Butte in 1975, having flunked out of college, he sends a letter back to his old writing instructor at Berkeley describing how he has become a "caretaker for fifteen hundred potted cannabis plants" concealed in one of the abandoned mines, "the only cash crop you can grow in Butte." Later he writes, "The ugliest town in America just got uglier. We lost our only green place. The Company thought there just might be something to dig for there. So Columbia Gardens became the Continental Pit." Lynch is bitter that no one voiced opposition to the loss, that "Butte never had a 'People's Park' fight," he writes, as Berkeley did in the late '60s.

Bitter and ineffectual, Harry Lynch comes to represent a pathological type one finds among the lifelong residents of Butte and other cities in America plunged into industrial decay—the citizen plagued with *ressentiment* who nevertheless refuses to leave. Such disgruntled inhabitants prefer nursing their contempt for their neighbors rather than sublimating their anger as art: "I've tried to write stories about Butte," he says. "But who wants to read about Butte?—least of all here in Butte."

But Harry hates visitors from out of state almost as much, especially "vacationing businessmen from Texas or New York who come to fish the 'pristine streams' of the state they're starting to call 'the last best place.' Needless to say, they don't visit Butte, and I don't tell them what's flowing into those streams from my hometown." At least his critique of the *Our Lady of the Rockies* statue high atop the East Ridge is redeemed by its mixing of religious metaphors: "Our very own Golden Calf worshipped above our genuine poison River Styx."

Bryant's novel stands in the gap between twenty-first-century novels of Butte that rehearse some aspect of its actual history as part of their plots and those that largely ignore the historical past in order to focus their plots on Butte in the present. The next several novels may occasionally refer to some elements of Butte's famous history, but those references here are generally in passing, since these novels depict Butte as the town as it exists in the present, or at least the present of the last twenty-five years.

REIF LARSEN

The Selected Works of T.S. Spivet (2009) only begins in Butte—but what a beginning! The book is worth reading simply because it is such a curiously unusual book—a phrase that applies to many of the books Butte has inspired over the years, beginning with *The Story of Mary MacLane*. The twelve-year-old protagonist of Larsen's novel lives on Coppertop Ranch near Divide, Montana, about sixteen miles from Butte. A compulsive cartographer, he maps everything around him the way Pepys kept diaries. The narrative involves a cross-country journey from Divide to Washington, D.C., limiting the novel's time in Butte to the first several chapters. But Larsen avoids relying on what have now become clichés—the brutality of the mines, the labor strife, the Copper Kings and so on—and instead brings to life the post-historic Butte in a moderately convincing way.

In Larsen's book, the reality of the working miners—so much a focus of many previous Butte novels—has been attenuated to a brief abstraction: "For eight hours the world was hot, dark, sweaty, and three feet wide," explains a character summarizing Butte's mining history as it is evoked in the bones of its headframes dotting the hill.

Our twelve-year-old protagonist's sense of Butte varies widely from that of previous generations. Butte has now been relegated to history

A photo of Butte looking east from near the School of Mines, circa 1996. *Photographer Aaron Parrett.*

books, a repository for the fragile record of its past protected in libraries and collections:

> *When Father was not too grumbly, I would catch a ride with him into town on Saturdays so that I could visit the Butte Archives. The archives were crammed inside the upper story of an old converted firehouse, and the space could barely contain the haphazard array of historical detritus stuffed into the grillwork of its shelving. The place smelled of mildewed newspaper and a very particular, slightly acidic lavender perfume that the old woman who tended the stacks, Mrs. Tathertum, wore quite liberally.*

In Larsen's book, Butte has become an echo of itself: though it once flourished as "the richest hill on earth," it has now become a living memory bank of all the lives the hill consumed in its historic century-and-a-half run from a wilderness cracked by quartz veins in 1865 to a ghost city perched on the edge of the unfathomable Berkeley Pit. T.S. Spivet immerses himself in the depths of the Butte–Silver Bow Archives the way miners once descended into the mines, one obvious difference being, of course, that what was drudgery for the miners offers Spivet personal reward. He has a clear stake in his explorations and discoveries:

> *Traces of love and hope and despair were sprinkled throughout these official documents, and more interesting still were the journals I occasionally discovered behind a canvas box…yellowing photographs, banal diaries that occasionally would reveal a moment of intense intimacy if you stuck with their pages long enough, bills of sale, horoscopes, love letters, even a misfiled essay on wormholes in the American Midwest.*

T.S. Spivet's cartographic explorations in Butte and its archives connect the city to the rest of the country, his maps and legends fleshing out the traces of immigrants and their lives, immortalizing the city as "Butte, America." The effect is further enhanced by his cross-country journey from West to East—the reflected echo of a historical wave that first traveled the other way as fortune seekers and waves of immigrant laborers made their way from New York and Boston to Butte.

PAULS TOUTONGHI

Pauls Toutonghi's *Evel Knievel Days* may qualify as the most bizarre novel ever to be set in Butte. The initially intriguing conceit of this book involves a young man of Egyptian extraction coming of age in modern Butte. The protagonist's name is Khosi Clark-Saqr, and as it turns out, his great-great-grandfather was none other than William A. Clark, the Copper King. The first quarter of the book is an interesting view of Butte that confirms its enduring multicultural roots by offering an unusual perspective on the modern city circa 2008. But a third of the way in, the book has a major shift in mood as the ghost of William A. Clark, who talks suspiciously like the cowboy in *The Big Lebowski* (played by Sam Elliott), starts visiting Khosi and giving him advice on how to find his lost father in Cairo.

On the one hand, Toutonghi succeeds in bringing twenty-first-century Butte alive—the title, for example, takes its name from the festival held every summer since 2002 in celebration of one of Butte's most notorious citizens. Toutonghi also positions Khosi as a guide for the William A. Clark Mansion Historic Site, giving him plenty of opportunity to comment on the Berkeley Pit and its poisonous lake, the obligatory history of the early Copper Kings and so forth. But the seasoned denizen of Butte will bristle at some lapses in verisimilitude: the Bitterroot River is nowhere near "just outside of Butte," for example, and nothing in the historical record indicates that William A. Clark spoke in a folksy drawl or ever manifested anything resembling a sense of humor. Nevertheless, it's interesting that Toutonghi uses Butte as a setting for conveying the experience of a young man of such mixed heritage. Like many authors, Toutonghi seems to seize on Butte because it represents the essence of the American story, right down to the very basic fact of its incredibly diverse ethnic history and the way it magnetically attracts some of America's most unusual personalities to its streets.

Like other twenty-first-century writers, Toutonghi expresses a peculiar ambivalence for the Berkeley Pit: "I used to always think of the pit as a terrible scar, a pockmark in the skin of the city, of the state, of the country," confesses Khosi, "but as I stood there and replayed my strange last few days in my head, it looked almost beautiful. It was vast and aquatic and it was a contrast to the city that stretched up to its lip."

In one succinct and gravid passage, Toutonghi relates a conversation between Khosi and his mother, who is trying to get her half-Egyptian son

to explore his "broader culture." "I want to connect you to where you came from," his mother says, to which he rebuts, "I came from Butte, Montana." His mother can only say, "It's more complicated than that," which is fundamentally the situation of every American.

JAKE MOSHER

Jake Mosher's sophomore novel, *Every Man's Hand* (2002), presents a vivid and convincing portrait of modern-day Butte, even though the book, purporting to be comedy, amounts to a parody of itself. The characters here lack verisimilitude and become rather obvious caricatures: a Native American Indian "chief," for example, made to utter such cringe-worthy sentences as "Me wantum more, waiter," and "Drinkum, drinkum, drinkum."

Like Toutonghi, Mosher recognizes that the Berkeley Pit with its poisonous lake has become the dominant feature of the town, but in the spirit of Butte's counterintuitive (and crass) sense of taste, he describes it as a work of art on par with the Italian masters:

> *The Berkeley Pit should be the eighth wonder of the world, he thought… The more you looked into it, the deeper it appeared…In his opinion, the Berkeley Pit was a testament to man's ability to carve. Michelangelo might look at a block of marble and see an angel waiting inside for his chisel, but to look at a mountain and see a hole to hell, now that took vision.*

Similar passages appear in Larsen's and other modern Butte novels and express a version of what the industrial archaeologist Patrick Malone has referred to as "the industrial sublime."

Mosher also documents how Butte's slide from prominence in Montana history is articulated in its visible infrastructural shift from the hill to the flats: "The broad street sloped away before him, off the hill, out toward the flats at the base of the Highlands, where modern Butte was trying to distance itself from her dilapidated uptown sections," an event he pegs as "crawling away from her cocoon."

Shortly afterward, they pass a house with a surreal tableau arranged on its front porch: "A mannequin on the porch with her hand between Abraham Lincoln's legs," a testament to the tendency of Butte residents to make artworks of their otherwise collapsing homes.

NASA photo ISS013-E-63766 (Berkeley Pit), circa 2008. *Courtesy of NASA.*

In an especially poignant scene, one character nails perfectly the sense of hundreds of church basements in Butte as he describes the scene at the Butte Adult Activities Center: "There was the kitchen. One glance in that direction was too many. Yellow linoleum, wallpaper peeling behind the commercial sized stove, cheap framed painting of Crazy Horse erected by Hector, immense iron crock of spaghetti, punch bowl of cherry Kool-Aid on the long counter, humming white refrigerator."

Mosher's Butte is the Butte of Harrison Avenue and the Plaza Mall as much as it is the well-worn nostalgic groove of Park and Main uptown, which lends the book an aspect of honesty in spite of its otherwise salient flaws.

JON JACKSON

Jon Jackson started writing in the late '60s and published his first mystery in 1975. Several of his Sergeant Mulheisen novels, including *Deadman* (1994), take place in part in Butte, though *Go By Go* (1998) is a thoroughly Butte novel. This ambitious effort features as its main character Goodwin Ryder, a loose characterization of Dashiell Hammett, and the plot involves the aftermath of the infamous murder of Frank Little. Here the conceit is that Ryder—like Hammett—gets called to testify before a congressional subcommittee investigating the communist threat, and Ryder conceives of the witch hunt as an opportunity to revisit the events of many years prior, when he operated as a Pinkerton detective in Butte.

Critics were tepid in their response to the book. While Jackson is clearly a competent writer, the consensus seemed to be that he had difficulty gaining traction covering already well-trodden ground.

Sandra Dallas

Sandra Dallas's debut novel, *Buster Midnight's Café* (1990), takes place in modern-day Butte. It connects only incidentally to Butte's rich history and reads rather like *Cold Sassy Tree* or *Steel Magnolias* set in Butte. The book lacks any real verisimilitude, in large part because the cadence and style of the narrator sound more appropriate for Mississippi than Montana, which is surprising given that Dallas is from Denver. In any case, the book feels as if its author perhaps drove through Butte, maybe even stopping for lunch at the M&M Café, but drove home to start writing without ever having gained a sincere sense of what the place is actually like. As Joseph Kinsey Howard once wrote, "Butte is a manner of thinking and speaking, a way of life. Or to put it quite inanely, 'a state of mind.' Let the sociologists deny it…They haven't lived in Butte. They couldn't."

In Dallas's case, practically every element westerners associate with Butte is added to an ornamental string of clichés: Cornishmen and their pasties, the Columbia Gardens, legends of the Copper Kings, Venus Alley hookers and so on. In short, the narrative feels like a knock-off rather than anything resembling the genuine article.

Heather Barbieri

Bestselling author Heather Barbieri chose Butte as a setting for her debut novel, *Snow in July* (2004), because her family has close ties to the town. Her father grew up in Butte, and his father was a miner. The novel received mixed reviews, but the criticism seemed a reaction to contrivances of plot. Barbieri's novel follows the narrator, Erin Mulcahy, as she and her mother are compelled to deal with her older sister Meghan, an incorrigible drug addict whose neglect of her two small children borders on abuse. This uninviting story line nevertheless captures an aspect of Butte mostly ignored in the other contemporaneous novels: there's no denying that Butte possesses its share of America's underclass. Yet the easy availability of heroin here strains belief, and the writerly tenor of the carefully crafted prose is slightly off key for Butte. Nevertheless, when Barbieri imagines the *Our Lady of the Rockies* statue atop the East Ridge "coming alive and stomping down Main Street like Godzilla," she does capture something of an irreverence in the face of bad taste that many twenty-first-century residents of Butte harbor.

Our Lady of the Rockies: an immense iron sculpture atop the East Ridge near Butte. Photographer: Richard Gibson. *Courtesy of Richard Gibson.*

The Butte of the late twentieth- and early twenty-first-century writers is a museum of its earlier self, a sort of historic recycling center that will either give the city a second wind or eventually lead to its own cannibalistic annihilation. In a fine essay on the difficulty of making sense of the post-industrial Butte, Edwin Dobb intuited that Butte, at least in its guise as "The Mining City" or "The Richest Hill on Earth," was dead: "Whatever Butte's future may hold, it won't look like that, not ever again. All our talk about the spirit of the place enduring, which is true enough, can also be a form of whistling in the dark, of not mustering up the courage to look into the casket and at long last acknowledge what has happened."

But like many of the twenty-first-century novelists choosing Butte as a setting for their literary exhibitions, Dobb sees in Butte the revelation of something even more powerful than the husk of its vanishing history. In fact, he expresses some sympathy for "the disappointed, disoriented souls who come looking for the Montana they've drooled over in travel brochures and glossy magazines, not realizing that when they enter Butte they leave Montana behind." In a sense, the "vernacular reality of Butte," as Dobb calls it, is a kind of lesion on the collective consciousness of America, a monstrous archetype of the American dream.

Yet Butte—ever resilient—manages to emerge from even this scenario. Twenty-something novelists who weren't even born when the Anaconda Company finally and dishonorably dissolved find themselves looking in Butte for some element of the American story that either transcends or haunts the mythology of Montana as the Last Best Place.

Chapter 7

MINING TOWN CINEMA

Butte on Film

A "beaut" from Butte!
—*Homer Simpson, while watching Miss Montana's appearance on the Miss*
America pageant

Naturally, a mining city with a history as rich as Butte's would attract the documentary filmmaker, and Butte has been the subject of dozens of excellent nonfictional films. But a number of fictional films have been set in Butte as well, many of them based on the novels discussed in this book. The cinematic efforts associated with Butte appear early: Mary MacLane wrote and starred in *Men Who Have Made Love to Me* in 1917, although that film, shot entirely in Chicago, had little to do with Butte aside from its star.

A ROMANCE OF BUTTE (CIRCA 1920)

Around the same time, however, a short feature film called *A Romance of Butte* was shot on location in Butte. Lost for nearly a half century, a copy of the film was discovered in a basement in the 1960s and was preserved on DVD in 2005. The brief narrative (the film clocks out at sixteen minutes) clings to a simple, somewhat melodramatic plot, but the film preserves cinematic images of some vanished neighborhoods in Butte, and more than two minutes of the film are devoted to a stunning full panoramic shot of

hundreds of Butte faces gathered together uptown. The film credits Walter Steiner as director and Beverly B. Dobbs as cinematographer. Interestingly, the film centers on the Atherton family, perhaps an homage to Gertrude Atherton for her *Perch of the Devil*. The film features many fascinating shots of Butte around 1920, including an arrival of an electric locomotive at the old Milwaukee Road Station uptown and two panoramic shots of the corner of Park and Main Streets, one of which captures the frantic bustle of Butte's uptown back in the day—at least four streetcars pass through the throngs of people in the sequence, as do several automobiles. Dating the film precisely is a challenge, although the film cannot be earlier than 1916, the date that the Milwaukee Road electrified its rail lines from Harlowton, Montana, to Idaho. In the shot of the Rialto Theatre uptown, the marquee advertises *Huckleberry Finn*, the earliest film version of which appears to have been 1920. The most compelling shot in the film shows droves of miners walking home at the end of a shift down the steep Anaconda Road.

The plot involves an enterprising young man from the lower class who woos the daughter of a wealthy mine owner. At first unnoticed by the young woman, the hero wins the affection of both the girl and her father when he thwarts a plot by some agitators to destroy her family's house with an anarchist's bomb. In the sixteen-minute film, the romance is perforce a whirlwind affair, but the film closes with some charming footage of the couple three years later pushing a stroller along what looks like Montana Street uptown.

PERCH OF THE DEVIL (1927)

Gertrude Atherton's *Perch of the Devil* was turned into a film in 1927, thirteen years after the novel was published. Directed by King Baggot, the film starred Mae Busch, an actress now remembered primarily for her comedy work, particularly with Laurel and Hardy. The film more or less follows the plot of the book, which may be boiled down to two women vying for the affections of the male lead. The climactic scene is set in a mine and presents the two women fighting in a shaft that suddenly floods. The heroine rescues her archenemy from the torrent and is reunited with her lover.* The film appears to have been shot entirely in Hollywood, with no actual footage of Butte.

*. The 1927 feature film should not be confused with the 1960 documentary of the same name, a film about the 1960 miners' strike in Butte.

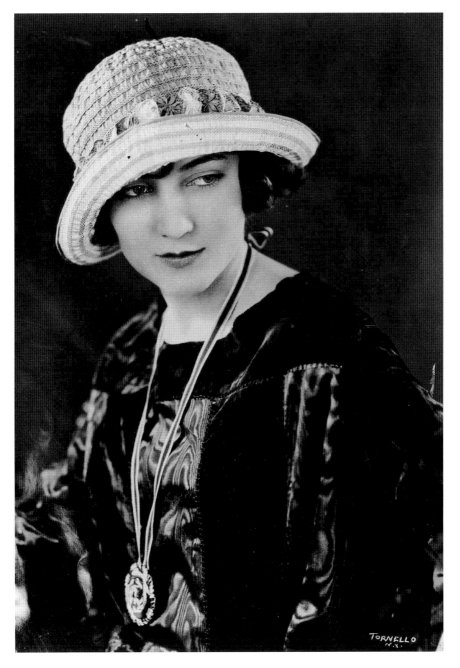

Movie star Jane Winton, who played Ora Blake in the 1927 film of Gertrude Atherton's *Perch of the Devil*. *Courtesy of the U.S. Library of Congress.*

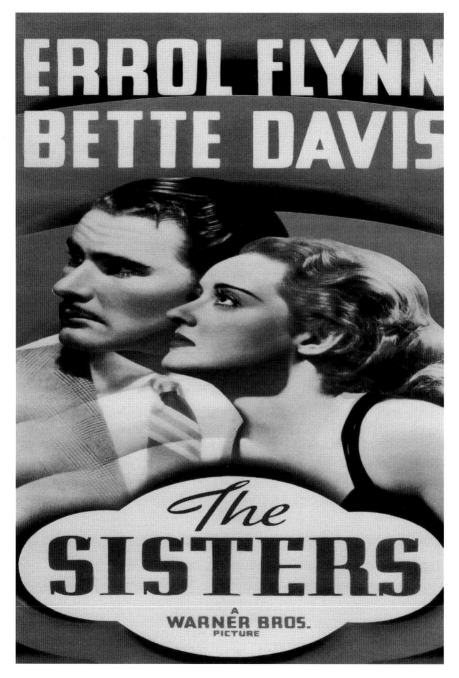

Movie poster for *The Sisters* (1937). *Courtesy of Brian Murray, Dublin.*

THE SISTERS (1937)

Myron Brinig's *The Sisters* (1937) was adapted for film in 1938 under the direction of Anatole Litvak, starring Errol Flynn and Bette Davis. The story opens in Butte circa 1904, but the leading lady falls in love and moves to San Francisco, where the main plot of the film unfolds. Critics generally consider the treatment of Butte to be superficial.

EVEL KNIEVEL (1971)

Robert Craig Knievel, better known as Evel Knievel (1938–2007), the world-famous stunt daredevil, was born and raised in Butte. Marvin Chomsky directed a biopic in 1971 starring George Hamilton. The film is standard B movie fare but features some excellent shots of Butte circa 1970, including some footage of the East Ridge and the upper reaches of the Butte hill, including Walkerville. One sequence early in the film was shot in the M&M bar. The film, to its credit, also contains authentic dialogue in the Butte scenes: one character in a bar says to another, for example, "How's she goin'?"—long considered the standard Butte greeting. After Mary MacLane, Knievel might qualify as the most famous personality to emerge from Butte, though he has as many detractors as fans.

THE KILLER INSIDE ME (1976)

The Killer Inside Me, directed in 1976 by Burt Kennedy, stars Stacey Keach and Susan Tyrell. This film, also set in Butte and filmed entirely on location, draws together the persona of Butte and one of the masters of noir fiction, Jim Thompson, who wrote the novel of the title in 1952, though he set it in a small Texas town. The shift to Butte works well precisely because of Butte's long history of political and municipal corruption. The film features a convincing and powerful performance by Keach as Sherriff Lou Ford, a man who terrorizes the business community and brutalizes those he loves as he struggles with mental illness, all the while charming the townsfolk as a benevolent and protective lawman.

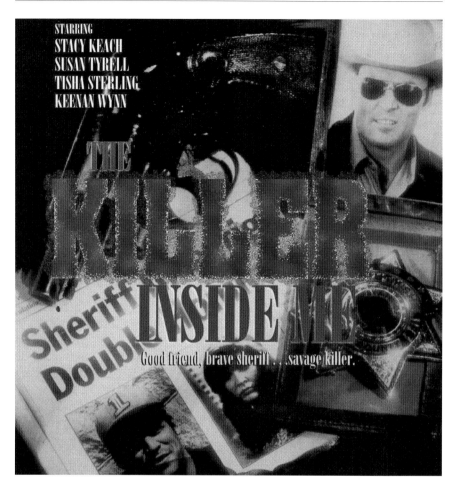

Movie poster for *The Killer Inside Me* (1976).

The film features some great footage of Butte, including sequences down in the Berkeley Pit and out on the flat near the Four Mile. There are also some excellent scenes filmed around the School of Mines.

BELL DIAMOND (1986)

Bell Diamond was directed by independent filmmaker Jon Jost, was shot in Butte on a shoestring budget and starred many local residents. It tells the story of a Vietnam veteran whose marriage deteriorates when he and

his wife are unable to have children because of his exposure to Agent Orange during the war. The film garnered positive reviews for both the convincing storyline and the quality of the acting. Kristi Hager, one of the actors in the ensemble that Jost collected, explained that Jost's unscripted approach to the film may have been minimalist but exposed "some sharp edges" to the characters and the emotional tension between them. Film critic Armond White wrote that Jost's casting of amateurs succeeded "almost too well," as he threw the actors and their "desert of inarticulate, tight faces" into "some of the finest pictorial representations of the working-class West imaginable—cloud filled skies, cyclone fences, desolate factories, pipelines, old tanks." Other critics compared the style to the work of John Cassavetes, with its spare and improvisational tone. The technique lent itself particularly well in Butte, which makes *Bell Diamond* (named after one of the mines in Butte) one of the few fictional films available that accurately captures the character of Butte—including the starkness of its post-industrial landscape as well as the sensibility of its people.

John Powers wrote in *LA Weekly* that "Jost's method of narrating his tale will not be to every taste, for, though it's visually impressive, not one frame could be confused with commercial cinema." Jost himself explained his method in a commentary on *Bell Diamond* on his website:

> *Story-wise, I decided that I better come up with a starter to get things going, so using things I'd learned during the summer, I cooked up an opening scene in which—for all practical purposes—the lead character, Jeff and his wife split up. From there on the cast took it, scene at a time, stretched out over a casual 6 or 8 weeks shooting period. Most of these people either worked, or were unemployed but caught jobs as they could, and our shooting was fully set around their availability. At the start of the film I really had no money, though I'd applied for an NEA grant which I was completely certain I would not get: in the application I'd written only that I'd go to some place with high unemployment and make a fiction with whoever wanted, period. I didn't think I'd get very far. And then, well into working on the film, arrived the grant and $25,000. I offered each actor some modest money and they all refused, though I felt some of them thought I'd known I'd get the money all along and had sort of tricked them.*

Jost went on to say that although he felt that people in Butte were generally disappointed with the film, at a screening in Portland, Oregon, "a fellow

came up to me after, saying he'd gone to the screening because he was from Butte, and he said I'd nailed the atmosphere. For me that is the best kind of critique I could hope for."

DON'T COME KNOCKING (2005)

More recently, Wim Wenders, the idiosyncratic director who stunned American audiences with his elegant *Wings of Desire* in 1987, collaborated with Sam Shepard to write *Don't Come Knocking*, inspired by and set in Butte in 2005. Sam Shepard starred in the film alongside Jessica Lange. The film was a box office disappointment and received mixed reviews. For the most part, the film failed to impress the locals, even though it manages to capture a semblance of what Butte has become in the twenty-first century.

Shepard and Wenders had earlier collaborated on the cult classic *Paris, Texas* (1984). *Don't Come Knocking* was filmed almost entirely on location in uptown Butte. The film was a bust, having been budgeted for $11 million but grossing less than $1 million in its first year. Nevertheless, Butte shines under the cinematic treatment of Wenders, and film critic Roger Ebert gave it a thumbs up, writing that "[t]here are scenes that don't even pretend to work. And others that have a sweetness and visual beauty that stops time," a sentiment that in a sense captures Butte itself. Perhaps without realizing it, Ebert's comments on the film actually reveal real-life elements of the town that no doubt attracted Wenders and Shepard to the location in the first place. Consider Ebert's puzzlement at one of the film's key scenes:

> These people move in intersecting orbits through Butte, a city that seems to have essentially no traffic, and no residents not in the movie except for a few tavern extras and restaurant customers. Consider a scene where the enraged Earl throws all of his possessions out the window of his second-story apartment and into the street. His stuff remains there, undisturbed, for days. No complaints from the neighbors. No cops. Howard Spence spends a night on the sofa, sleeping, thinking and smoking. It's a lovely scene.

The fact is, that scene could easily happen in Butte in actual life, and so that moment in the film achieves a kind of verisimilitude that would be impossible in most places.

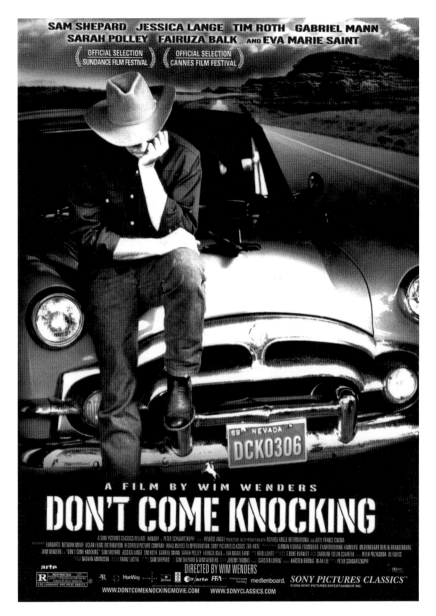

Movie poster of *Don't Come Knocking* (2005), Sony Pictures.

Ebert also noted the obvious homage to the work of American painter Edward Hopper of *Nighthawks* (1942) fame, since many of the shots seem framed according to his principles of realist minimalism.

WHO KILLED COCK ROBIN? (2005)

Filmmaker Travis Wilkerson drew critical raves for his 2002 documentary on his hometown of Butte, *An Injury to One*. His attempt to translate that message into a fictional feature titled *Who Killed Cock Robin?* met with little success, however. (*Variety*, for example, gave it a mere two stars.) Critic Scott Foundas called the mostly failed attempt "ponderous," lamenting that a strong message of "corporate malfeasance and the decline of workers' rights in America" was marred by "amateurish performances and sheer didacticism." The film showcased at the Sundance Film Festival, where it received tepid reviews, though even the harshest critics agreed that Wilkerson's effort showed promise. A more charitable assessment would simply note that the film has difficulty escaping the documentary idiom Wilkerson seems more comfortable with.

The film does convey the anomie and frustration of modern youth in Butte, especially (as the title indicates) its young men. The soundtrack, made up largely of old-time folk and gospel tunes, adds a haunting gloss and reinforces the anxiety wrought by an apparent return to the Gilded Age in the early twenty-first century. Moreover, Wilkerson's camerawork (much of the film appears shot in 8mm) appropriately captures post-industrial Butte and, like Jost's earlier film, uses the Butte landscape to great advantage. On top of that, some of the dialogue regarding Butte is spot on: "There'll always be Butte," says one character, surveying the town from atop the hill. Another character comments, "A lot of color here," and pauses, then adds, "A lot of gray here, too."

THE YOUNG AND PRODIGIOUS T.S. SPIVET (2013)

Reif Larsen's debut novel, *The Selected Works of T.S. Spivet*, was adapted into a 2013 film by Jean-Pierre Jeunet, who stunned audiences with *Amelie* (2001). Unfortunately, Jeunet preserves little of the conceit of the novel and instead crafts an altogether different story in the film. Butte is entirely absent from the film aside from a perfunctory shot supposed to be the Butte–Silver Bow Archive; the whole film was shot in Canada. The protagonist of the film is an eccentric boy genius as in the book, but lost altogether is the motif of his cartographic obsessions.

OTHER BUTTE APPEARANCES IN TV AND FILM

Butte has figured incidentally in hundreds of films and television shows. Most noteworthy perhaps are the two episodes of *Route 66* in the '60s filmed in Butte: "Blue Murder" and "A Month of Sundays" (1961). Beavis and Butthead refer to Butte regularly, and their feature film *Beavis and Butthead Do America* (1996) featured a segment on Butte, perhaps for obvious reasons. Given the proclivity the writers of *The Simpsons* have for literary and cinematic allusion, the epigraph to this chapter (from the episode "A Streetcar Named Marge," season 4) might very well have been inspired by the 1913 short western film *A Beaut from Butte*, directed by Arthur Hotaling. Most western films that reference Butte seem to do so not out of any deference to its singular mining history but because it is likely the only town name viewers would recognize as being in Montana.

Known for a century as the Mining City and celebrated for decades as "the richest hill on earth," Butte happens to possess a ready-made backstory for the interested novelist. In addition, for the aspiring filmmaker, Butte happens to remain something of a living museum and monument to much of that history, with its towering headframes lingering here and there across the hill and, more recently, the man-made canyon of the Berkeley Pit encroaching on the town. Otherwise unremarkable films—*Evel Knievel*, for example—are redeemed by their footage of Butte's stark industrial skyline, as are films outside the pale of the mainstream, such as *Bell Diamond*.

In the same way that post-industrial Butte has drawn the attention of many novelists in search of the unusual western narrative, it seems likely that modern Butte will continue to attract the attention of auteurs in pursuit of the same American story.

Afterword

"And...Away Runs Jenny through the Cactus..."

At its height, Butte's population, including surrounding communities, probably never exceeded 100,000 people, yet few cities in the United States of similar size can claim such a broad literary heritage. Authors who choose Butte as a setting routinely depict the town as a personality, a town not merely *with* character but a town that *is* a character. One cannot help but conclude that the fame of Butte in part rests on the attraction the city has held for fiction writers, and in turn, its reputation has been largely manufactured by writers such as Myron Brinig, Clyde Murphy and Dashiell Hammett and their progenitors: Josephine White Bates, Willis George Emerson and Berton Braley. For both reasons, Butte itself tends to be a central theme in nearly all Butte fiction.

But other themes emerge as well. For example, readers who explore this collection of fiction cannot help but be struck by the prevalence of crime in these novels—ranging from underclass corruption and violence to white-collar fraud and graft at the highest levels. In this regard, one can hardly avoid drawing the conclusion that the fiction merely holds a mirror up to the real world: after all, Butte's history reveals an inordinately violent and corrupt town. Throughout that history, the line of demarcation between criminal and municipal authority has been obscured by politics, corporate interests and an enduring conception of Butte as a "wide-open town." Probably no work of Butte literature (but sadly not a novel) has captured this theme as well as Jerre Murphy's *A Comical History of Montana* (1912), which documents how the Amalgamated (later the Anaconda) Company

put its heel to the neck of Montana for decades. "There never has been a political campaign in Montana since the Amalgamated Copper Company was organized which the New York bosses have not attempted to direct to a result," he wrote, and "in all the campaigns of Montana history there never before was such glaring use and abuse of corporate power in the selection and election of candidates as was exercised in the contest of 1910."

It's also worth reiterating the emphasis in Butte literature on women and the unexpected prevalence of strong female characters, often during historical periods in which women were depicted as objects rather than subjects and nearly always relegated to roles supportive of male protagonists. Part of their prominence in Butte fiction can be explained by the number of female writers in the pantheon of authors who deal with Butte. But while a strong female protagonist is perhaps not surprising in the work of a woman like Josephine Bates, such a character appearing in a hardboiled detective novel—R. Francis James's *High, Low, and Wide Open,* for example—is striking and unusual for the genre, indicating the prevalence of strong women in Butte in real life, in this case borne out by the fact that the author's mother was a single mother active in feminist politics.

No doubt such fully dimensional and unconventional female characters were also inspired by actual celebrities such as Mary MacLane, herself a widely published writer, as well as by ordinary women in Butte who exhibited remarkable "plucky spunk," in the words of one *Daily Miner* writer in 1881. From its earliest days, Butte became widely known for its local characters, among whom were women like Madame May Maloy, who ran the Irish World Saloon (and brothel) on Mercury Street and who is remembered even today for unceremoniously expelling Carrie Nation from her establishment by way of a boot to the rear. But in a more mundane sense, women formed the foundation of the community. Women were wives and mothers, to be sure, both occupations overwhelming in their own right, but frequently they were the heads of families when their husbands were killed in the mines. Historian David Emmons described the frequency and impact of widowhood on Butte women in his book *The Butte Irish* (1989), remarking that, among just the Butte Irish, "The mines created more Irish widows— fifty to one hundred per year from accidents alone—than Irish fortunes," and one assumes the ratio would be no different for any other ethnic group in Butte. Women were shopkeepers, saloonkeepers and hotelkeepers and worked in virtually every capacity in Butte except in the mines. Hence, any writer who spent time on the hill could not help but notice that women in Butte composed a class perhaps even more worthy of characterization than

ordinary men, who, if they were not at the top of the corporate or industrial heap, were merely drudges below the earth.

Similarly, an inchoate concern for nature and protecting the environment emerges from the majority of the works about Butte. Even Josephine Bates in 1888 commented on the effects of mining, and practically every writer after her perceived the widespread pollution in and around Butte as a kind of innate quality contributing to its character. Innate or not, most writers—like most ordinary citizens—could not help but wonder what kind of damage the sulphur smoke and tailings were heaping on Butte's citizens. As Mary MacLane noted in 1902, the streets of Butte were devoid of even a blade of grass because of the poisonous air constantly settling on the ground.

In our era, when the specters of global climate change and environmental degradation have grown acute, the Butte novels are worth looking at for their contemporary discussion of the ubiquitous pollution that has plagued Butte since human beings began the toxic and noxious practice of smelting ores in the area back in the 1880s. Butte residents have always harbored ambivalent feelings about the environmental ruin that marks their city: at the same time that the tailings and scarred hillsides offered a tangible if "ugly" reminder of the great wealth that had been extracted, they became a symbol of community pride—if only because it took an especially hardy and seasoned person to live among such conditions.

Similarly, while contemporary culture pundits like William Langewiesche scratch their heads at Butte's failure to corrode away into nothingness, novelists keep coming back to make sense of its strange contradictions. But then Langewiesche, like Joseph Kinsey Howard's exemplary sociologist, didn't seem to "get" Butte at all: "Montanans elsewhere call it 'Butte, America' in a disparaging way, as if it were somehow a separate and alien place," he wrote, clearly misunderstanding both Butte *and* "Montanans elsewhere."

An entire battalion of historians has produced a multitude of excellent books documenting and explaining the phenomenon of Butte, often with a passing reference to the writers it harbored at different times throughout the roughly 150-year span of its life. But few of them have remarked on the sheer volume of literary works about Butte, and fewer still have sought an investigation of common themes within them. Conversely, the novelists seem to have mined those history books the way the prospectors and speculators once mined the hill, and they continue to uncover promising veins and leads long after the wealth has gone east. One good reason for more comprehensive investigations of Butte's literature is that performing

such labor provides opportunities for analyzing and understanding what makes Butte the unusual heterotopia it is. Reworking Butte's literary history seems especially timely given what seems to be a return to the Gilded Age and the resurgence of corporate political power.

This book has tried to make clear that the story of Butte is in many ways a sort of condensed allegory of the American experience, a narrative distilled from a potent mash of rugged industrialism, indomitable pride and a relentless struggle between wealthy plutocrats and the working poor. At the same time, certain features of that narrative percolate out in a way that reveals Butte as a place unlikely to be confused with any other. One feature is linguistic: people in Butte have a way of talking even today that marks them out from other parts of the state and, indeed, from the rest of the country. "How's she goin?" for "hello" and "Tap 'er light!" for "goodbye" are two obvious examples, but there are many more. Sadly, many of the expressions so well documented in, for example, Joe Duffy's *Butte Was Like That* are fading away as the last of the old-timers still using them succumb to time and history.

One of the expressions from the early days of Butte in particular seems to crystalize an aspect of the Butte psyche that has persisted from the beginning, a sort of sanguine resignation to the forces of fate. As the hail begins to fall and he realizes he has locked himself out of his truck, for example, you might hear a fellow from Butte mutter, "And…away runs jenny through the cactus." The rumored origin of the expression runs something like this: an old prospector, having exhausted himself and his provisions only to strike a blind lead, decides to renounce the West and turn for home, only to see his lone mule vanishing over the horizon, along with the last of his worldly possessions. *And…away runs jenny through the cactus.* Things are never so bad that they couldn't be worse. The fact that Butte can conjure such a vivid metaphor in the face of disaster says a lot about its character and underlines its eternal literary optimism.

Even Joseph Kinsey Howard, never afraid or ashamed to expose the corruption and corporate Bunco in Butte, couldn't help but end his 1947 essay, "Butte: City with a 'Kick' in It," on a positive note:

> *I, too, have stood at the head of Antimony Street, on the slope of Big Butte, after sunset. I have watched the lights come on, watched the tired and shabby city disappear, watched the moon come up to search among the peaks until it finds, suddenly, the white glitter of the snow on the Highlands. Then I have seen the new city, the city of lights, thrust itself up from the*

scarred soil of Butte and hang, wondrously suspended, in the moon-misty sky. And, while I watched, I have heard the long, lonely whistle of a train echoing across the great plateau; a whistle, I am sure, which is like no other in the world. Yes, I know what you mean, Ma'am. Butte is beautiful.

The novels of Butte depict an inordinate amount of human misery, and they catalogue a depressing inventory of environmental abuse. They display a rogues' gallery of corporate villains alongside the usual crowd of petty and vicious scoundrels who appear wherever fortune offers even a hint of favorable odds. But the novels of Butte also present a town where ordinary people endure and triumph in small, appreciable ways. They show unremarkable people as remarkably honest, surprisingly philosophical and occasionally even worthy of emulating or living up to.

As a famous prospector once observed, "A city set on a hill cannot be hid." The novels of Butte, America, comprise a literature at once regional and national. These stories escape the slope of the richest hill on earth and flow inevitably into the stream of the world's deep history, into the pool of what makes the mineral world fully human.

Selected Bibliography and Suggestions for Further Reading

Algren, Nelson. *The Last Carousel*. New York: Putnam's, 1973.

Astle, John. *Only in Butte: Stories off the Hill*. Butte, MT: Holt Group, 2004.

Atherton, Gertrude. *Perch of the Devil*. New York: Frederick A. Stokes, 1914.

Baker, Ray Stannard. "Butte City: Greatest of the Copper Camps." *Century* (April 1903): 870–79.

Barbieri, Heather. *Snow in July*. New York: Soho, 2005.

Bates, Josephine White. *A Blind Lead: The Story of a Mine*. Philadelphia: Lippincott, 1888.

Braley, Berton. *Pegasus Pulls a Hack: Memoirs of a Modern Minstrel*. New York: Minton Balch, 1934.

———. *The Sheriff of Silver Bow*. New York: Bobbs-Merrill, 1921.

———. *Shoestring*. New York: Sears Co., 1931.

Brinig, Myron. *Singermann*. New York: Farrar and Rinehart, 1929.

———. *The Sisters*. New York: Farrar and Rinehart, 1937.

———. *The Sun Sets in the West*. New York: Farrar and Rinehart, 1935.

———. "The Synagogue." *Munsey's Magazine* (March 1924): 259–69.

———. *This Man Is My Brother*. New York: Farrar and Rinehart, 1932. Published in Great Britain as *Sons of Singermann*. London: Cobden-Sanderson, 1932.

———. *Wide Open Town*. Helena, MT: Farcountry Press, 1993. Original edition: New York: Farrar and Rinehart, 1931.

Bryant, Dorothy. *The Berkeley Pit*. Livingston, MT: Clark City Press, 2007.

Calvert, Jerry. *The Gibraltar: Socialism and Labor in Butte, Montana, 1895–1920*. Helena: Montana Historical Society Press, 1988.

Cohan, Charles Cleveland. *Born of the Crucible*. Boston: Cornhill Co., 1919.

Connolly, Christopher. *The Devil Learns to Vote*. New York: Covici, Friede, 1938.

Copper Camp: Stories of the World's Greatest Mining Town Butte, Montana. WPA project. New York, 1943.

Croly, Jennie June. "Atlanta Council of the General Federation of Women's Clubs." N.p., 1895.

Cullum, Ridgeway. *The Sheriff of Dyke Hole*. Philadelphia: Jacobs, 1909.

Cushman, Dan. *The Old Copper Collar*. New York: Ballantine, 1957.

Dallas, Sandra. *Buster Midnight's Café*. New York: Random House, 1990.

Davis, George Wesley. *Sketches of Butte: From Vigilante Days to Prohibition*. Boston: Cornhill Company, 1931.

———. *Sulphur Fumes, or In the Garden of Hell*. Los Angeles: Times-Mirror Press, 1923.

Dean, Patty, ed. *Coming Home: A Special Issue of* [Drumlummon Views] *Devoted to the Historic Built Environment & Landscapes of Butte and Anaconda, Montana* (Drumlummon Institute & Montana Preservation Alliance, 2009).

Dobb, Edwin. "Notes on an Erotics of the Mining City." *Buildings and Landscapes: The Journal of the Vernacular Architecture Forum* (Spring 2010): 1–12.

Doig, Ivan. *Sweet Thunder*. New York: Riverhead, 2013.

———. *The Whistling Season*. Orlando, FL: Harcourt, 2007.

———. *Work Song*. New York: Riverhead, 2010.

Duffy, Joe. *Butte Was Like That*. Butte, MT: Duffy, 1941.

Emerson, Willis George. *The Builders*. Chicago: Forbes & Co., 1906.

———. *Gray Rocks*. Chicago: Laird & Lee, 1894.

Emmons, David M. *The Butte Irish: Class and Ethnicity in an American Mining Town, 1875–1925*. Urbana: University of Illinois Press, 1989.

Fairman, Paul W. *Copper Town*. Toronto: Harlequin, 1952.

———. *The Heiress of Copper Butte, aka the Montana Vixen*. New York: Lancer, 1952.

Finn, Janet L. *Mining Childhood*. Helena: Montana Historical Society Press, 2012.

Fisher, Arthur. "Butte." In *These United States*, edited by Daniel Borus. Ithaca, NY: Cornell University Press, 1992.

Freeman, Harry C. *A Brief History of Butte, Montana, the World's Greatest Mining Camp; Butte above and below Ground*. Chicago: Henry Shephard Co., 1900.

Ganz, Earl. "Myron Brinig: Montana Writer." *The Speculator: A Journal of Butte and Southwest Montana History* 2 (Winter 1985): 3–15.

Gide, Andre. "American Writing Today: An Imaginary Interview." *The New Republic* (February 7, 1944): 186.

Gutfeld, Arnon. "The Murder of Frank Little: Radical Labor Agitation in Butte, Montana, 1917." *Labor History* 10, no. 2 (1969): 177–92.

Halverson, Cathryn. *Maverick Autobiographies: Women Writers and the American West, 1900–1936.* Madison: University of Wisconsin, 2004.

Hammett, Dashiell. *Red Harvest.* New York: Knopf, 1929.

Handy, Moses P. "Literary Chicago." *Munsey's Magazine* (October 1894): 77–88.

Jackson, Jon. *Go By Go.* Tucson, AZ: Dennis McMillan, 1998.

James, R. Francis. *High, Low, and Wide Open.* New York: Macauley Co., 1935.

Johnson, Dorothy. "Review of *The Old Copper Collar.*" *Montana Magazine of Western History* 7, no. 4 (1957): 58.

Lahey, Ed. *The Thin Air Gang.* Livingston, MT: Clark City Press, 2008.

Langeweische, William. "The Profits of Doom." *Atlantic Monthly* (April 2001). www.theatlantic.com/magazine/archive/2001/04/the-profits-of-doom/302177.

Larsen, Reif. *The Selected Works of T.S. Spivet.* New York: Penguin, 2009.

Layman, Richard. *Shadow Man: The Life of Dashiell Hammett.* New York: Harcourt Brace Jovanovich, 1981.

Leipheimer, E.G. *First National Bank of Butte.* Butte, MT: First National Bank, 1952.

Lutz, Giles A. *Halfway to Hell.* New York: Fawcett, 1963.

MacCuish, David. *Do Not Go Gentle.* New York: Doubleday, 1960.

MacLane, Mary. *I, Mary MacLane: A Diary of Human Days.* New York: Stokes, 1917.

————. *My Friend, Annabel Lee*. Chicago: Herbert Stone, 1903.

————. *The Story of Mary MacLane*. Chicago: Herbert Stone, 1902.

Malone, Michael P. *The Battle for Butte: Mining and Politics on the Northern Frontier, 1864–1906*. Seattle: University of Washington Press, 1981.

Mangam, William D. *The Clarks: An American Phenomenon*. New York: Silver Bow Press, 1941.

Marcosson, Isaac Frederick. *Anaconda*. New York: Dodd & Mead, 1957.

Maury, Reuben. "Hymn to an Oasis." *American Mercury* (October 1925): 190–96.

McCaig, Donald. *The Butte Polka*. New York: Rawson & Wade, 1980.

McCaig, Robert. *Haywire Town*. New York: Dodd, Mead, 1954.

[McKown, Mrs. T.D.] *The Devil's Letters to Mary MacLane*. Chicago: Inter-State, 1903.

McLure, Charlotte. *Gertrude Atherton*. Boise, ID: Boise State University, 1976.

McNelis, Sarah. *Copper King at War: The Biography of F. Augustus Heinze*. Missoula: University of Montana Press, 1968.

Mosher, Jake. *Every Man's Hand*. Guilford, CT: Lyons Press, 2002.

Murphy, Clyde. *The Glittering Hill*. New York: E.P. Dutton, 1944.

Murphy, Jerre. *The Comical History of Montana*. San Diego: E.L. Scofield, 1912.

Murphy, Mary. *Mining Cultures: Men, Women, and Leisure in Butte, 1914–41*. Urbana: University of Illinois Press, 1997.

Nyland, Waino S. "A Famous Mining Camp in Literature." Unpublished manuscript at Butte–Silver Bow Archives, 1926.

O'Malley, Richard K. *Mile High, Mile Deep*. Missoula, MT: Mountain Press, 1970.

———. *Mile High, Mile Deep*. Livingston, MT: Clark City Press, 2007.

Polito, Robert. "Introduction [to Dashiell Hammett]." *Maltese Falcon*. New York: Knopf, 2000.

Rakove, Jack N. *Original Meanings*. New York: Knopf, 1996.

Roeder, Richard. "The Copper Pen: Butte in Fiction." In *Montana and the West: Essays in Honor of K. Ross Toole*, edited by Rex Myers and Harry Fritz. Boulder, CO: Pruett Publishing, 1984.

Ruffolo, Frank. *Butteopia*. Butte, MT: Silver Street Group, 2006.

Sales, Reno H. *Underground Warfare at Butte*. Caldwell, ID: Caxton Press, 1964.

Savage, Thomas. *Lona Hanson*. New York: Simon and Schuster, 1948.

Shores, Robert. *The Story of Willie Complain*. Butte, MT: Inter-Mountain, 1903.

Stuart, Granville. *Montana As It Is; Being a General Description of Its Resources, Both Mineral and Agricultural*. New York: C.S. Westcott, 1865.

Terris, Virginia R. "Mary MacLane—Realist." *The Speculator: A Journal of Butte and Southwest Montana History* 3 (Summer 1985): 42–49.

Thompson, Jim. *The Killer Inside Me*. New York: Fawcett, 1952.

Toole, John. *Red Ribbons: A Story of Missoula and Its Newspaper*. Helena, MT: Falcon Press, 1989.

Toutonghi, Pauls. *Evel Knievel Days*. New York: Crown Publishers, 2012.

Wells, Camden. *The Improper Bostonian*. Boston: Branden Press, 1971.

Wheeler, Leslie. "Montana's Shocking 'Lit'ry Lady.'" *Montana Magazine of Western History* 27, no. 3 (1977): 20–33.

Wheeler, Richard. *The Richest Hill on Earth*. New York: Forge, 2011.

Winchell, Alexander. "Butte." *National Council for Geographic Education* 10, no. 3 (1911).

Wixson, Douglas. "Growing up Radical in Missoula and Butte: Norman Macleod, Poet, Editor, Novelist (1906–1985)." *North Dakota Quarterly* 74 (Summer 2007): 6–50.

Young, Otis E. *Western Mining: An Informal Account of Precious-Metals Prospecting, Placering, Lode Mining, and Milling on the American Frontier from Spanish Times to 1893*. Norman: University of Oklahoma Press, 1970.

INDEX

About the Author

Aaron Parrett was born in Butte, Montana. He earned a degree in philosophy from the University of Montana and holds a master's and a doctorate in comparative literature from the University of Georgia. He has published widely in many fields, including fiction. He has also gathered accolades for his original music, including the 1996 album *The Sinners*. In 2004, he won the People's Choice Award from the Montana Historical Society for his article "Montana's Worst Natural Disaster: The 1964 Flood on the Blackfeet Reservation."

Visit us at
www.historypress.net
..
This title is also available as an e-book